GIRL ON GIRL

ART AND PHOTOGRAPHY
IN THE AGE OF THE FEMALE GAZE

LAURENCE KING

Published in 2017 by
Laurence King Publishing Ltd
361–373 City Road
London EC1V 1LR
United Kingdom
enquiries@laurenceking.com
www.laurenceking.com

A catalogue record for this book is available
from the British Library.

ISBN: 978-1-78067-955-6

Design by Charlotte Coulais | En Ville Studio

Printed in Hong Kong

CHARLOTTE JANSEN

GIRL ON GIRL

ART AND PHOTOGRAPHY
IN THE AGE OF THE FEMALE GAZE

LAURENCE KING PUBLISHING

CONTENTS

Two years ago, three girlfriends and I found ourselves in a spa where nudity was not essential but pretty much required. In the changing room, we were a little taken aback but not entirely unsurprised – 'I guess this *is* Berlin', we shrugged – and undressed. I'd never seen my friends naked before, and I kept my eyes averted out of tense politeness. By the end of the day, we were unselfconsciously sizing each other up, making comments like 'your butt is like mine, but a little curvier' in the same voice we might use to discuss our elbows or knees. There was endless delight to be found in this measuring exercise, our chests and waists and legs lining up on a scale of infinite variety, our bodies the same but different.

I thought about this when Charlotte asked me to write this foreword. As an editor, I've written and commissioned stories about women trying to carve out a space for themselves – and other women – in everything from politics to art. What these attempts have in common is a willingness to assert their right to take up space, and nowhere is that more obvious than in photography.

A woman taking a photograph of a woman isn't just performing a political act; it is also a powerful act of imagination. If each picture taken creates an image of a new reality, then this is one that suggests the exclusion of men. The photograph may allude to masculinity, but both its gaze and subject remain female. If the male gaze is thought to be toxic, the female gaze is a corrective. It is a perfect, virtuous circle, and entirely natural. A filmmaker once told me, 'I know the female gaze is a thing, because I do it.'

And there are multiple ways of seeing, too. In *Girl on Girl*, there are Lebohang Kganye's spectral family portraits, but flip a few pages and you see Aneta Bartos's painterly images of female eroticism. Where men appear, as in Pixy Liao's self-portraits with her boyfriend, Liao is in charge: manipulating his body, obscuring his face with her hair.

I'm not convinced there is a definitive way to describe the female gaze. Is it cool, dispassionate, ironic, sublime, or tender? Maybe it is all these things – and much of the joy of this book lies in the multiplicity of its portrayals of women. We have not yet begun to understand the magnitude of what the female gaze may be, but we are slowly starting to grasp what it could be. *Girl on Girl* is a step in that direction.

When we finally put aside ideas of what female bodies should be – hidden or exposed, sources of embarrassment and censure – we can actually begin the task of looking. That day in the spa, after my friends and I had whiled our afternoon away, we looked at each other in the foggy shower room, and I saw the women around me as they were. And then we put our clothes on and went out into the night.

Zing Tsjeng
Editor, *Broadly* magazine

Learning to look at women

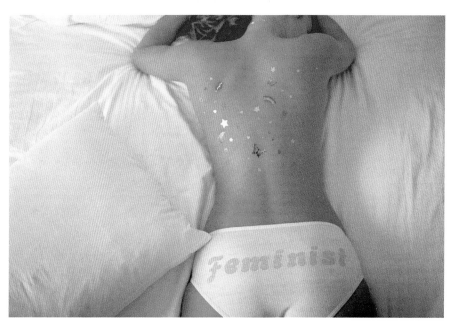

Mayan Toledano, *Sherris in Palm Springs*, 2014

On my computer screen is a half-naked young woman. The flawless, golden brown skin of her back is decorated with a cornucopia of tiny, sparkly stickers of rainbows, stars, kisses, dolphins, butterflies. Simple cotton underwear – powder pink to match the bed sheets she lies on – clasps to the cheeks of her bottom. Across the knickers a single word is printed in pink: 'Feminist'.

This photograph (by Mayan Toledano) made me angry. It would pop up again and again in my field of vision and everywhere from *The New York Times* to Tumblr. If you've used the internet in the last two years, the chances are it will be familiar to you too, and perhaps you had the same gut reaction to it as me. At the same time, it was making a huge impact. It seemed to capture the cultural predicament of the age of the female gaze: how should we look at women?

There is a fundamental pleasure in looking at women that is undeniable and unavoidable and tends to complicate the central place women have in visual culture. In the past, photographs of women were made by men for a capitalist economy to favour the male gaze and feed female competitiveness. Female visibility is therefore a fallacy: we see photographs of women every day, but we are used to looking at them in a few specific contexts: on products and billboards, in shop windows and magazine covers, in erotica and pornography. They appear similarly online, in the thick and fast slew of the trillion photographs we collectively produce and share every year. Yet photographs of women are far more provocative and complicated than these viewing circumstances prescribe.

Over the last five years, however, a growing number of the photographs of women we look at on a daily basis are being produced by women. The fact that women are taking more photographs of women – both themselves and others – than ever before is something that deserves attention. Does it matter whether Toledano's image was

shot by a man or a woman? I believe it does. When I started this book, two years ago, I was motivated not by the idea of 'female photography' (there is no such thing) but by the way in which the mainstream media was describing this unprecedented phenomenon of female photographers who photograph women. The dominant rhetoric gives us a narrow idea of why and how women photograph women – and what they have to offer.

The very particular place of the photograph of a woman in contemporary culture means we scarcely pause to take a second or prolonged look, but swipe swiftly on. This unequal treatment of photographs of women unfortunately connects to a wider gender inequality that affects every single country in the world. If we aren't able to see more than an expression of feminism or femininity in a photograph of a female figure, how can we expect to see more than this when we encounter women elsewhere?

My project is pro-women, but that of the artists featured in this book isn't necessarily. I wanted to embrace all kinds of photographs of women by women to bring them together – not to show how they are similar but to present how photographs of women are not always about feminism and femininity (although some, of course, are). We are so used to seeing images now in juxtaposition, that all photographs of women – static and silent – even when they're made for different purposes and audiences, are forced into a dialogue with one another. A selfie by Kim Kardashian proliferates so widely that we understand any photographic self-portrait through her lens. We see photographs women take – even of other women – as narcissistic, shallow, easy. This confluence of meanings doesn't benefit photographers or viewers. We often miss the nuances that reflect, in varying degrees, the photographer's perspective of living in our times – that doesn't only concern women.

Why is there a need to highlight *only* female photographers, if the aim is to come to photographs of women neutrally, without drawing attention to the gender of their maker? Given the long-established bias of the hetero-patriarchy, we still have centuries to go before the balance is redressed. At times, there seems to be little difference between how women photograph women and how men photograph women, but women have the right to self-objectify and to exploit without critique, just as men have been allowed to do since the earliest forms of art emerged. I came to see the feminist knickers as the beginning of an imperfect but very important process of emancipation.

Photographs taken by women do not only exist as a counterpoint to the male narrative. A photograph is an impulse – and challenge – to enquire, not a representation of truth. More often than not, I find that the photographs of women by women I see point me back to my own prejudice and misconceptions. Thanks to the generosity of the photographers on these pages, I had the chance to question my viewing habits and dig below the spectacle of surface.

In the hours I spent interviewing the 40 artists from 17 countries, I was often surprised by the reasons for which women photograph women. They can be a way to understand identity, femininity, sexuality, beauty and bodies. At times, using the female body is only a means to an end: it's a material that is available, over which the photographer-model has total ownership and final sovereignty. The photographs women take of women can be a tool for challenging perceptions in the media, human rights, history, politics, aesthetics, technology, economy and ecology; to get at the unseen structures in our world and contribute to a broader understanding of society. What you can get is not always what you might see.

Girl on Girl – as the title suggests – is ultimately a mediation on the agency women are taking over the images that are made of them. It's an investigation into the use and meaning of female photography now, bringing to light the plurality of situations in which a photograph is created and seen. The more we're exposed to different types of photographs of women – more women than we will ever meet in real life – the more we can learn. 'No genuine social revolution can be accomplished by the male', wrote the most radical feminist writer, Valerie Solanas. It would be naive to think that photographs of women can change the world, but we can learn a lot by looking.

ZANELE MUHOLI

A living archive

In autumn 2016, I was walking around the exhibition *Zanele Muholi: Isibonelo/Evidence* at the Brooklyn Museum, New York, the most significant museum survey of the award-winning artist's work to date. A young boy was there visiting with his mother. I watched him put the headphones on and stare up at the screen that was showing Muholi's 2012 video *Being Scene*, depicting blurry footage of bodies – lesbian couples, including Muholi and her long-term girlfriend – making love. I looked at his mother, who shrugged and laughed. This was probably the boy's first encounter with sex and it was an interracial, lesbian couple. It was a rare moment in which I realized how art can shift our perceptions of gender, sexuality and identity. 'I am hoping to break down those notions around what is to be seen and what is not', said Muholi in an interview about the exhibition at the time. 'I want to encourage young artists to think of photography as a possibility, as work – to think of art for consciousness, and in turn, museums as spaces where we can carve a new dialogue that favours us.'

Photography in South Africa has long been intertwined with its political turbulence, and Muholi, the first black, gay, South African photographer to make a significant space in the country's cultural history with her work, is part of a legacy of photographers who have challenged their reality from the inside, from South Africa's first black photographer, Ernest Cole, to David Goldblatt, George Hallett and Peter Magubane. In post-apartheid South Africa, however, inequalities persist.

With a background in journalism and activism for women's empowerment, in 2006 Muholi embarked on her best-known work to date, the ongoing project *Faces and Phases*, photographing members of the LGBTI community she belongs to, in townships of South Africa and the African diaspora. As an active, involved member of this community, Muholi is not distanced from her subjects: over the years, Muholi has returned to shoot follow-ups of them – an affirmation in a place where black lesbian, gay, bisexual, transgender and intersex people are persecuted.

To the outsider, what is striking about *Faces and Phases*, made up of more than 250 portraits, is not only the content of the images but also their quantity: this living archive of women has a powerful presence that contradicts the pandemic belief that being gay is un-African. Muholi explains: 'It's about claiming the spaces, taking back power, owning our voices and our selves and our bodies, without fear of being judged. Saying that we are here, without fear of being displaced.'

South Africa constitutionally has the most liberal attitude towards homosexuality on the African continent – same-sex marriage is legal, and anti-discrimination laws exist – yet brutal violence, corrective rape and murder are a daily reality for LGBTI people, and Muholi raises these tragic failures against her people through her work. Each portrait represents a different story – a struggle, and a triumph – but together they are part of a powerful collective force. Muholi's work is firmly rooted in the local, and her perspective of the situation she is living in, here and now. Yet a portrait in itself does not tell us the complexity of its subject's story. What we see first, and foremost, in Muholi's work, is the humanity common to all women, irrespective of their sexuality, gender or race. For Muholi, as a visual activist, photographs can change our world.

'It's about claiming the spaces,
taking back power, owning
our voices and our selves
and our bodies, without fear
of being judged.'

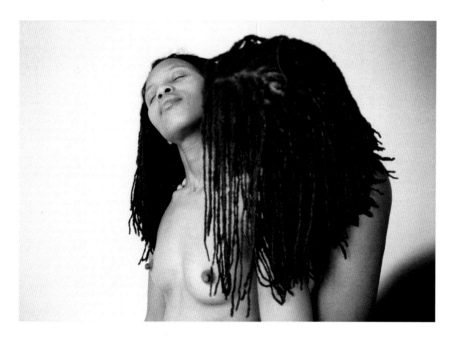

PAGE 10 *ZaVa III, Paris*, 2013
PAGE 11 *Katlego Mashiloane and Noshipo Lavuta, Ext. 2, Lakeside, Johannesburg*, 2007
ABOVE, TOP *Zinzi and Tozama II Mowbray*, 2010
ABOVE, BOTTOM *Beloved I*, 2005
OPPOSITE *Xana Nyilenda, Los Angeles*, 2013

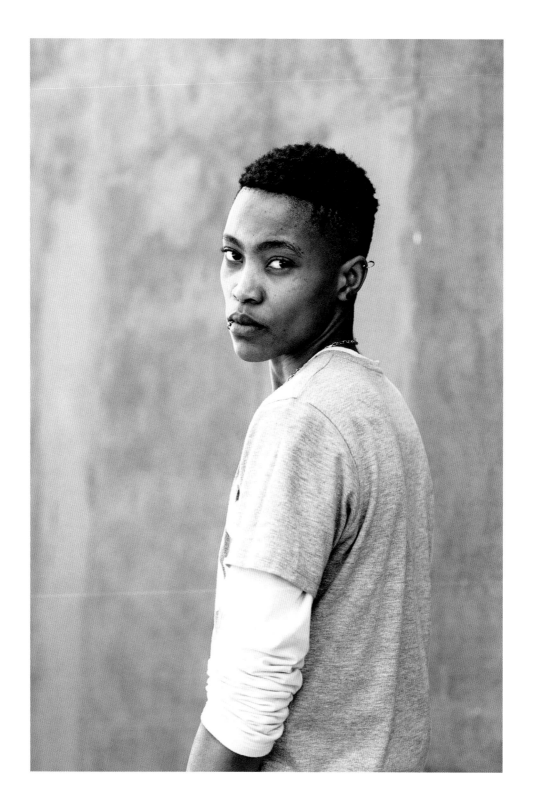

LALLA ESSAYDI

A space where differences converge

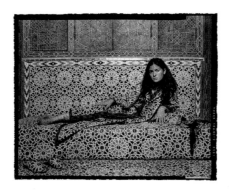

'I am neither victim nor representative', says Lalla Essaydi. As an Arab woman who photographs Arab women, her works reclaim the inherent beauty of the Islamic Arab culture in which she grew up in Morocco, as a reaction to how Arab women have been traditionally depicted by male European painters, as either oppressed damsels or seductive Jezebels. According to the Western, male gaze in these paintings, the Arab woman – especially the veiled woman – always has an erotic allure.

Essaydi started out as a painter, and her photography evokes various formal and conceptual ideas typical of Orientalist painting, while consciously breaking from the medium and the myths the genre has created about Arab women: 'Images of the harem and the odalisque are still pervasive today, and I am using the female body to complicate assumptions and disrupt the Orientalist gaze. I want the viewer to become aware of Orientalism as a projection of the sexual fantasies of Western male artists, in other words, as a voyeuristic tradition, which involves peering into – and distorting – private space.'

Space has multiple meanings in Essaydi's photographs of women, many of whom – like her – are women of the Arab diaspora now living in the West, who share the artist's experiences in negotiating their relationship to both cultures: 'The women in my photographs are both held within an actual space, and at the same time are confined to their "proper place", a place of walls and boundaries, a space controlled by men. These women have become literal odalisques' ('odalisque', from the Turkish, means belonging to a place).

Essaydi considers, too, the role of architecture in Arab culture in reinforcing gender roles. Her photographs are highly autobiographical, often using locations she spent time in growing up. In her *Converging Territories* series, shot in her childhood home in Morocco, she wanted to return to the space where 'a young woman was sent when she disobeyed, and stepped outside the permissible behavioural space as defined by my culture. Here, accompanied only by servants, she would spend a month, spoken to by no one, a month of silence. Confinement in actual spaces can be the result of transgressing metaphorical boundaries, of crossing into prohibited cultural spaces. Many Arab women today may feel the space of confinement primarily as a psychological one, but its origins lie, I think, in the architecture itself.'

Beauty is, of course, also a fundamental part of Essaydi's work. She celebrates the beauty of her female subjects and their surroundings, but consciously tries to control the way we see and understand that beauty: 'I have removed the nudity that is found in the paintings, and created instead "real" domestic scenes in which Arab women are engaging the viewer, disrupting the voyeuristic tradition and dictating how they are to be seen.' Essaydi reasserts, though, that her photographs are not intended to represent all Arab women, a culture that, as she points out, is far from monolithic. Her photographs are in this sense an individual expression of an identity that, in the past, has been dictated by foreigners. Her aim is personal and artistic: to contribute to a future archive of images by Arab women where they might freely depict their own experiences and perspectives of their culture.

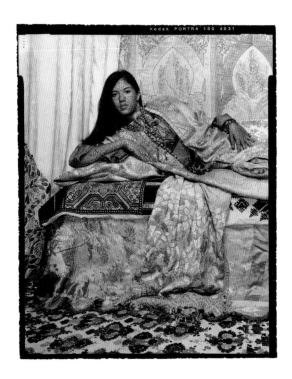

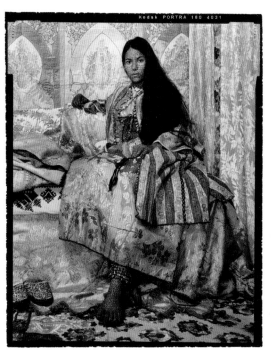

'I want the viewer to become aware
of Orientalism as a projection
of the sexual fantasies of Western
male artists ...'

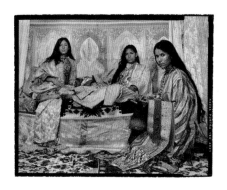

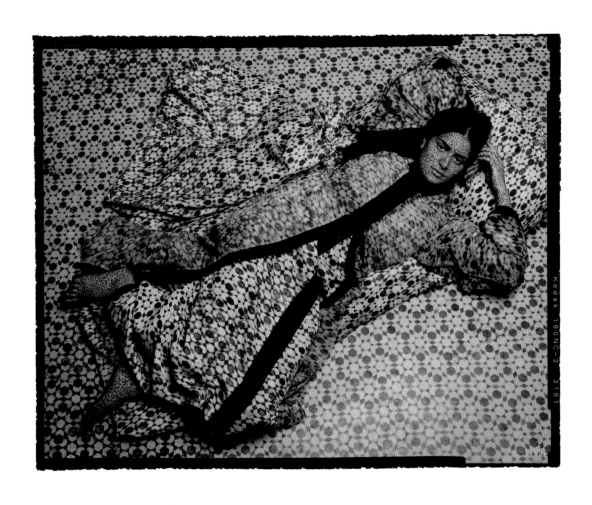

PAGE 14 *Harem #2*, 2009
PAGE 15, TOP *Harem Revisited #32*, 2012–13
PAGE 15, BOTTOM *Harem Revisited #31*, 2012
ABOVE *Harem #10*, 2009
OPPOSITE *Converging Territories #26*, 2004

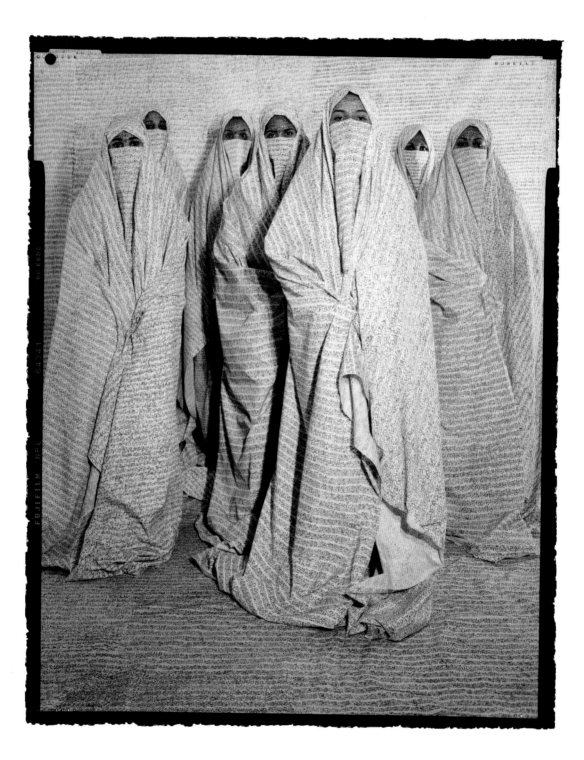

17

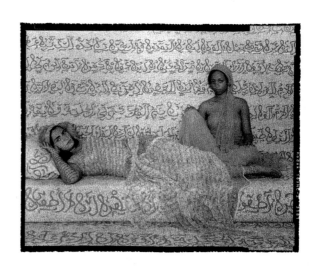

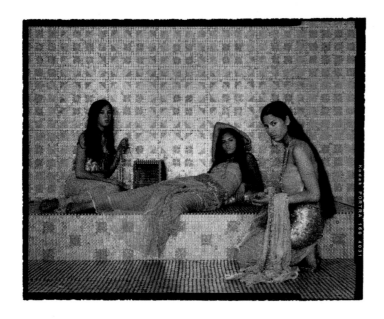

ABOVE, TOP *Les Femmes du Maroc: Revisited #5*, 2012
ABOVE, BOTTOM *Bullet #11*, 2012–13
OPPOSITE *Harem #13*, 2009

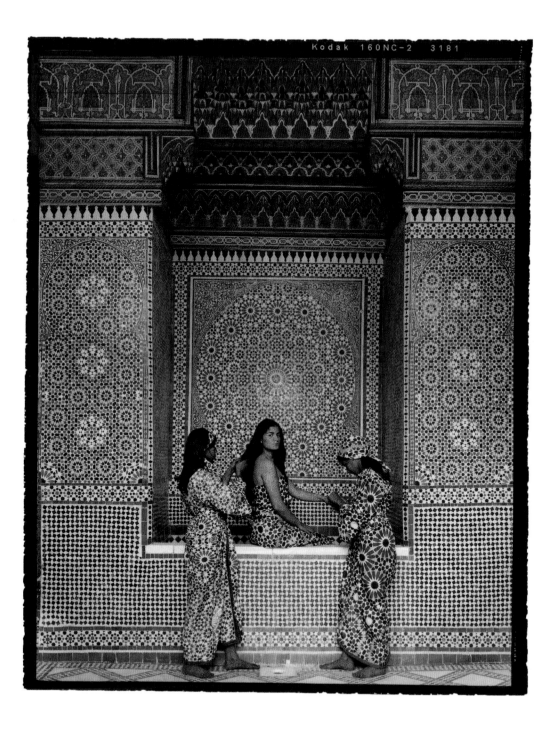

AYANA V. JACKSON

Re-presenting representation

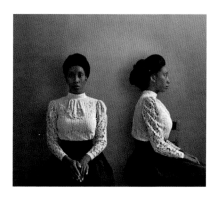

When I looked at Ayana V. Jackson's work, the first thing I saw was a woman's body. The artist photographs herself, but what she sees first is a black body and its representation and misrepresentation governed by the shifting power dynamics between the photographer and the photographed throughout history.

In Jackson's early work as a photographer, such as her documents of the hip hop scene in Ghana (*Full Circle*) and Afro-Mexicans in the Americas (*African By Legacy, Mexican By Birth*), she photographed others. Later, she began to find her privileged position as an American problematic in attempts to represent African and African diaspora bodies: 'If I were white and male, would my work be criticized differently? It made me question my relationship to my subject matter.' To interrogate the narratives on African and African diaspora identity and to re-present blackness in photography, Jackson felt it was necessary to rid herself of the power dynamic of the past – the photographer as colonizer, the subject as the colonized – and to point her camera at her own body.

Jackson believes in the power of photographs. Her images reference historical depictions of black bodies from the 19th and 20th centuries, restaging them in order to counter the narratives they impose in illustrating the trajectory of black identity: 'I'm not interested in binaries, that's the last thing I want to do with my work. My purpose is to get past them.' In her series *Poverty Pornography*, Jackson addresses the persistent photographic presentations of black bodies – especially African bodies – as impoverished, suffering, primitive, diseased or criminal. By photographing her black, female body naked, Jackson suggests there is a parallel between our consumption of hypersexualized black female bodies and our consumption of the suffering of black bodies: these bodies are objectified (literally turned into photographs for consumption) to arouse or shock the viewer, who remains at a safe distance from the subject.

The meaning of images inevitably changes with time: the reference for Jackson's *Demons/Devotees I* is an 1894 photograph taken by English missionary Alice Seeley Harris in the Congo Free State. Jackson's photograph is a reaction to the direct message that the photograph imparts, more than 100 years on, taken out of the broader context of Seeley Harris's work. Seeley Harris sought to lift the veil on the brutality of colonial rule, yet the information in the frame gives us another reading now: the European photographer dressed in white, standing above a crowd of naked bodies of Congolese children. With her image, Jackson enquires into the fundamentally problematic nature of the photograph as representation.

Jackson insists on this re-seeing of images by deliberately intervening in the black visual archive. Photographs now don't obey the linear trajectory of history; we come to see images in a way that isn't ordered chronologically, giving us a discontinuous idea of time. Jackson infiltrates the past and reinvents it, destabilizing the truth of the archetype image in photography. A story she tells me illustrates how effective this process can be. A student once approached her about her work *Destruction* (2011), a reimagining of an Eddie Adams photograph taken during the Vietnam War. However, the first image the student came across was Jackson's: they only understood Adams's earlier photograph through Jackson's lens.

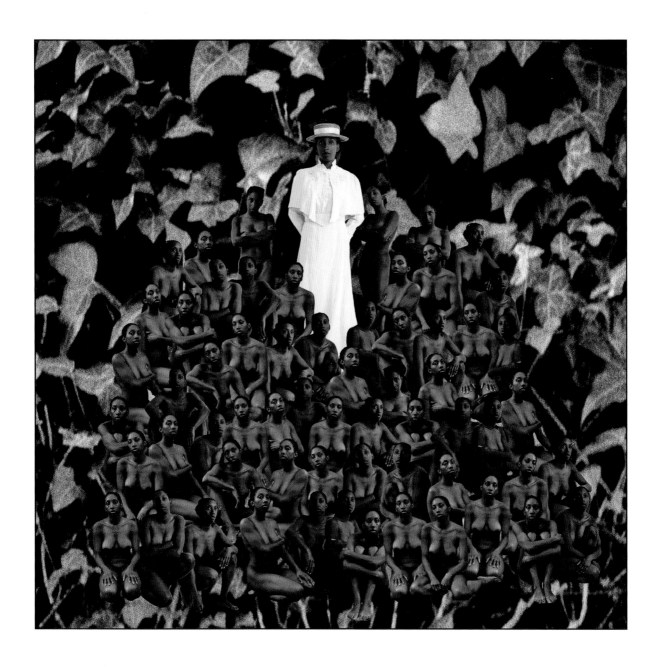

'If I were white and male, would my
work be criticized differently?
It made me question my relationship
to my subject matter.'

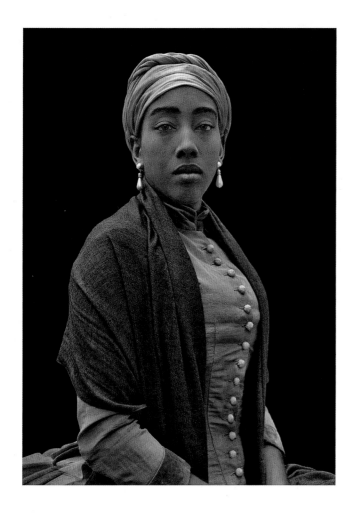

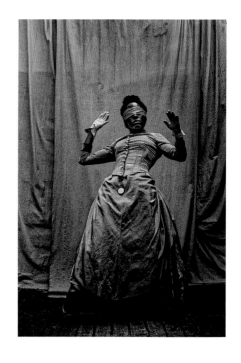

PAGE 20 *Prototype/Phenotype*, 2013
PAGE 21 *Demons/Devotees I*, 2012
ABOVE, LEFT *Cimarron* (from *The Becoming Subject*), 2015
ABOVE, RIGHT *The Existence of the Other as a Threat to My Life* (from *To Kill or Allow to Live*), 2016
OPPOSITE *Don't hide the blade/How do you think their women dress?*, 2013

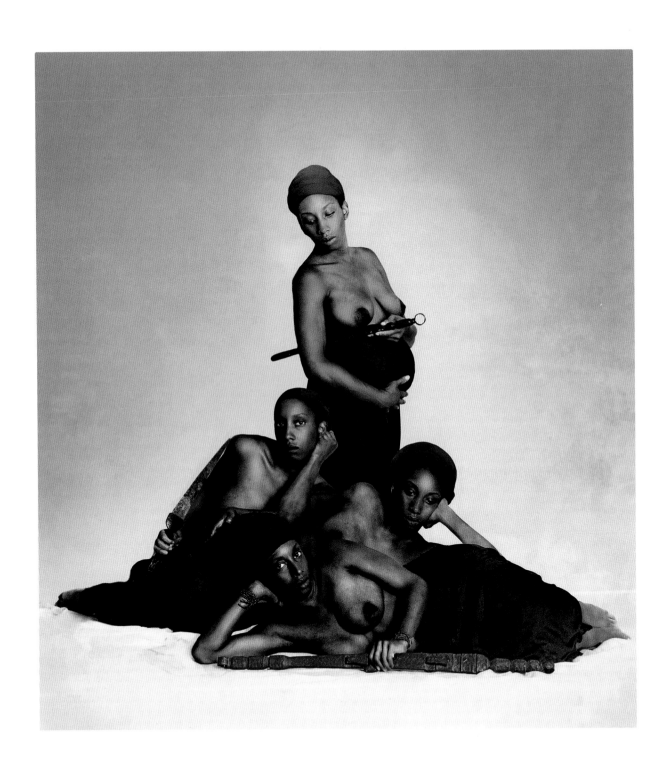

AVIYA WYSE

A proof of our existence

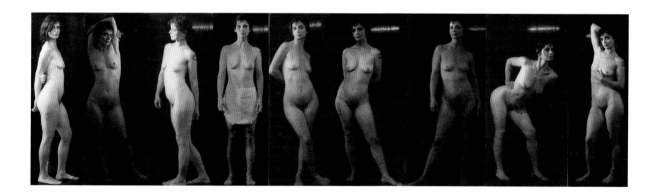

There are manifold demands on photographs of women. The model anticipates seeing herself: how will she look? Will it match her self-image? The viewer, meanwhile, is used to seeing many types of images of women in juxtaposition. This simultaneous viewing experience means we conflate meanings: we're conditioned to expect pleasure from looking at the female image in the commercial photograph, and in the non-commercial photograph (if that exists), we expect to find a comment on femininity or feminism. The popular rhetoric of 'raw' and 'honest' photography of women perpetuates as an alternative. What about the artist? What do they expect to see in their photograph? What the subject and the viewer want is often at a disjuncture with Aviya Wyse's intentions.

'They are my material', says Wyse on her approach to her subjects, some of whom are relatives and close friends, while others she meets by chance encounters and invites to be photographed later: 'It's as if I were going to buy wood. I'm using them, in a way.' In his *Small History of Photography* (1931), Walter Benjamin wrote that the rapidly changing world makes 'the sharpening of physiognomic perception a vital necessity'. Benjamin's view – inspired by August Sander's *Face of Our Time* – is lodged firmly in the photographic psyche. The physiognomic photographer documents the face and the body in order to give an insight into the inner character of the subject. In our times, these assumptions are problematic. Wyse works against this idea in her apparently physiognomic photographs: a body is only a body. It only shows itself. Wyse photographs without a will to add information; her subjects and her settings are stripped down, but paradoxically reveal less.

The more bodies she photographs, the less she sees her work as being about her individual subjects: 'Of course each model has their own biography, their own story, but there is nothing I'm revealing except their naked bodies – and their bodies in themselves do not reveal any other aspect about them.' Her photographs compel us to look at the present as it is already passing.

Wyse began photographing women following the death of her mother, when the artist was seventeen. Photographing women was at first a compulsive activity, a response to the void of her most fundamental female experience. Over the years her ongoing, extended series of portraits has become a humanist project: 'It's not about seeing the details of their nipples or their boobs and their bush … I am in a way *erasing* their unique traits. The more I photograph them, the more they become the same entity.'

Wyse is trying to get away from conveying any kind of 'ideal' in her photographs – masculine, feminine, human, aesthetic, artistic or otherwise. She does not try to empower or flatter her models or the female viewer. Her images are not reassuring. Rather than trying to understand them, or to exaggerate or conceal their bodily characteristics, Wyse simply presents presence; she gives us 'a circus of humans' as she refers to it, a hypnotic, undulating mass: 'I see my job as creating a proof of being here. That's it. It's a proof of existence.'

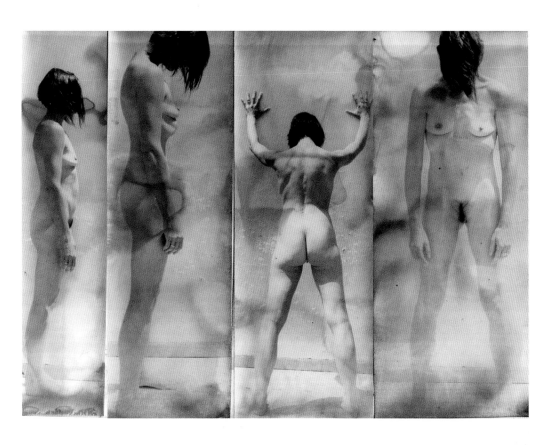

'I am in a way *erasing* their
unique traits. The more
I photograph them, the more they
become the same entity.'

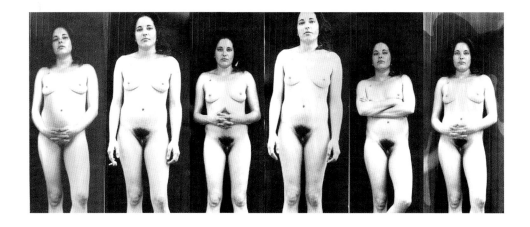

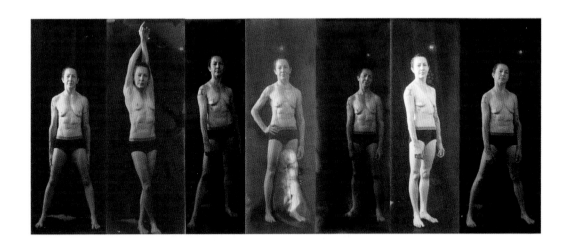

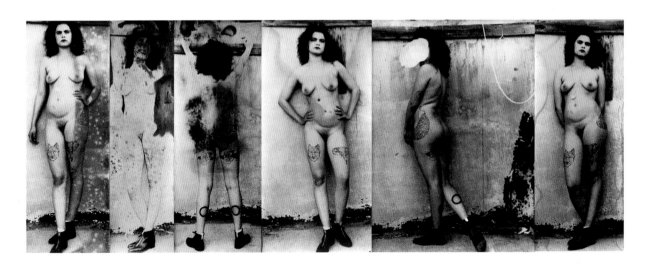

PAGE 24 *1.1*, 2015
PAGE 25, TOP *31.5*, 2015
PAGE 25, BOTTOM *12.1*, 2014
ABOVE, TOP *00.1*, 2015
ABOVE, BOTTOM *05.00*, 2015
OPPOSITE *09.1*, 2014

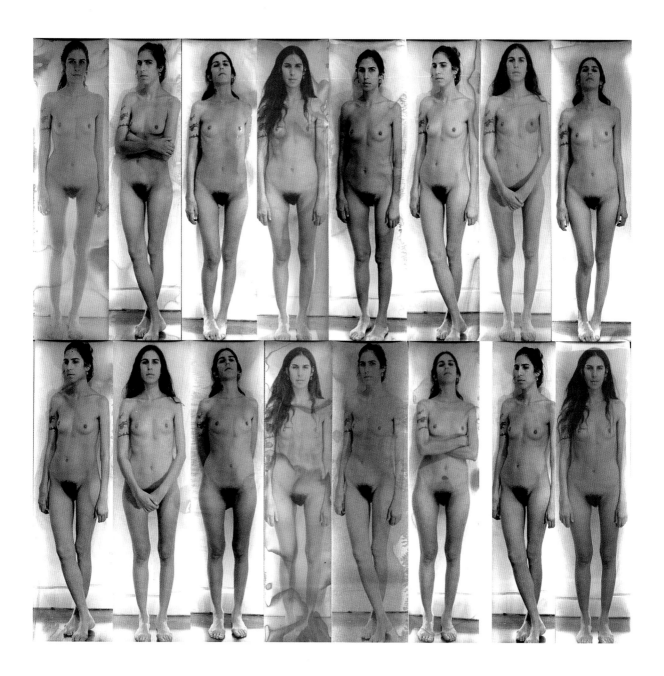

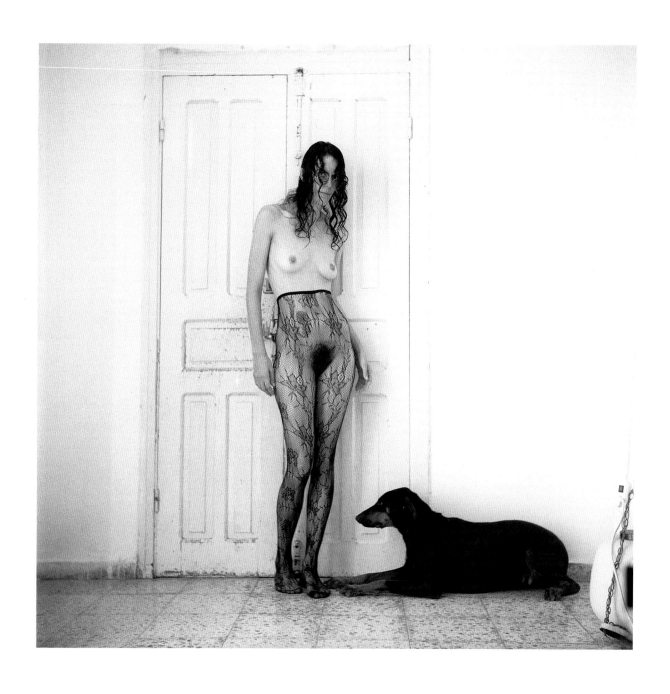

ABOVE *01.1*, 2013
OPPOSITE *04.2*, 2013

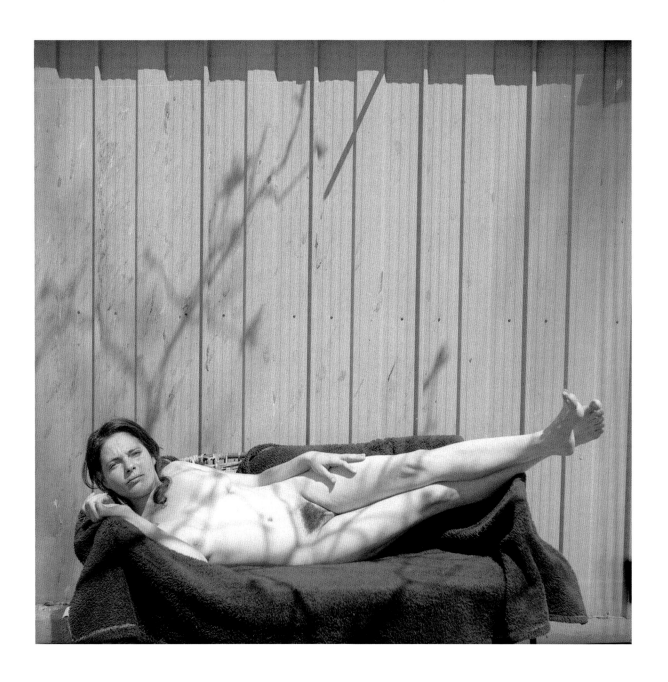

LEBOHANG KGANYE

Family photo albums, spectres and the self

'Photographs', writes Susan Sontag in her seminal book *On Photography*, 'give people an imaginary possession of a past that is unreal; they also help people to take possession of space in which they are insecure.' Four decades later, Lebohang Kganye has evolved the cathartic effect of taking photographs to a new space, where solace is found in embracing the constructed, edited memories contained in photographs as vestiges of existence. Kganye dissects portrayals of 'truth', both in photography and in personal history. Her images chronicle the 'unreal' visual past and create a dialogue with her own identity in the present: 'The idea of process is important to me. I research, read, collect, scan and put stuff up on my wall – emphasis on the word "stuff", because a lot of it does not make sense. I fill my walls with images sourced from the internet, books, magazines, photo albums, or anywhere really, and I enjoy this process of collecting. The photography begins much later.'

Three years after the death of her mother, Kganye felt compelled to map out her ancestry, geographically, physically and symbolically. She began to revisit places her mother had been to, and to reproduce old family photographs of her mother. She then digitally overlays the old and new images of herself and her mother to create striking photomontages that juxtapose the two. Dressed in the same clothes her mother wore in the original picture, and inhabiting the same poses, the spectral effect is striking: 'This was my way of marrying the two memories (mine and my mother's) to construct a new story and a commonality – she is me, I am her – while there remains so much difference and so much distance in space and time. The photomontages became a substitute for the paucity of memory, a forged identification and imagined conversation. Photographs present us not just with the "thereness" of the object but also with its "having been there", thus having the ability to present a past, a present and a future in a single image. In this sense, Roland Barthes argues that they are the modern ways in which we experience the reality of loss and, ultimately, death.'

In Kganye's two-part series *Ke Lefa Laka* (2013), she explores the ritual of the family photograph that commemorates and elevates an event in time, and then becomes a wider source of equivocal narratives later retold and passed down as heritage: 'Family albums are a significant part of family histories; the photographs are more than documentation of personal narratives – they become prized possessions, hearkening back to a certain event, a certain person, and a particular time. Family photographs are more than just a memory of moments, or people who have passed on, or reassurance of an existence; they are also vehicles to a fantasy that allows for a momentary space to "perform" ideals of "family-ness", and become visual constructions of who we think we are and hope to be, yet at the same time being an erasure of reality. I realized how the family album is composed of a selection of what shall be remembered and what shall be forgotten – therefore our histories become orchestrated fictions, imagined histories.' Kganye examines the depiction of her own history, but her photographs open up the broader complexity of how we construct ourselves in relation to history and politics. Kganye's investigations question what it is to be a woman, a daughter, a granddaughter, an artist – a young, cosmopolitan and urban South African today.

'I realized how the family album is composed of a selection of what shall be remembered and what shall be forgotten – therefore our histories become orchestrated fictions, imagined histories.'

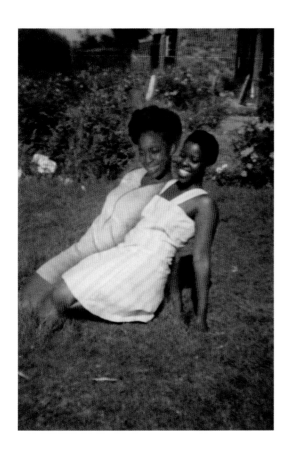

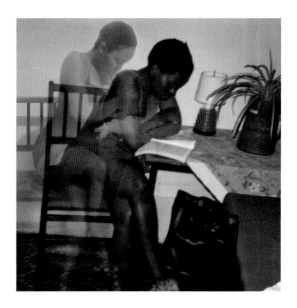

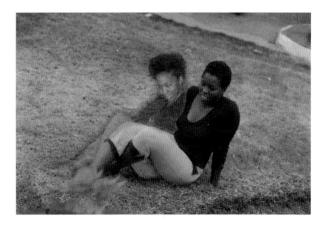

PAGES 30–33 All works from *Ke Lefa Laka/Her Story*, 2013

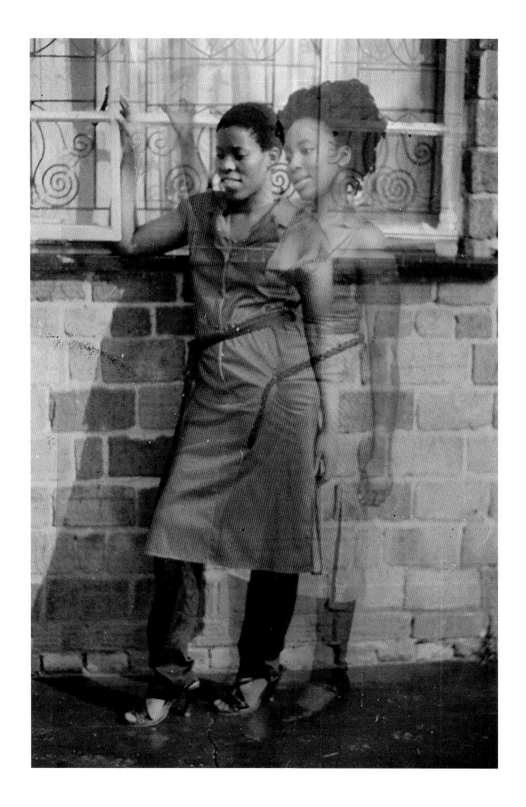

RANIA MATAR

Transitions and transience of the female experience

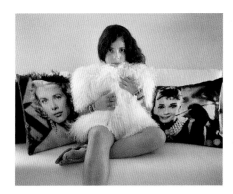

Rania Matar's work is interested in the formation of female identity, from the way pre-teens express their sameness and individuality, to other moments of transition that punctuate our lives: on the cusp of adolescence, becoming a woman, giving birth, being a mother, facing death. In her photographs, Matar focuses on girls and women in two cultures she has intimate knowledge of – American and Middle Eastern – giving the viewer another way to read her investigation into the liminal.

Like some of her female peers in photography, Matar chooses to shoot her younger subjects in their bedrooms, where the bedroom trope communicates an idea of the intimate, interior world of the subject, a symbol of their private sphere. Surprisingly, as the photographs accumulate into a series (Matar has published two books of the works to date), it's a sense of sameness, rather than individuality, that emerges. No matter their socio-economic or cultural environment, the girls of *L'Enfant Femme* (2016) and the earlier *A Girl and Her Room* (2012) give a picture of girlhood, where young women from very different backgrounds share more than their geographic separateness would suggest: 'This work is also about identity, both of the girls I photograph but also my own identity as a Lebanese-born-and-raised American woman with Palestinian origins. While the news from the Middle East tends to focus on our differences and on "them versus us", it was important to me to focus on our sameness, by focusing on girls in both cultures.'

Often, Matar's models face the camera, the photographer, and therefore the viewer, with a direct look. There is an affinity between the girls and the older woman who photographs them: each girl is evidently aware of the camera, and of a prosthetic memory being created for their future, an image of themselves they will keep and remember. Matar, too, points the camera through the prism of her own experience, as a woman and mother to two daughters – this exchange between the photographer and the photographed, the one looking back wistfully, the other looking determinedly forward, constitutes the feeling of great sincerity in Matar's work. We see young girls as they want to be seen, emulating the older women they admire. We feel the photographer searching for the comfort of sameness. At the same time, the viewer is aware of their very real social, economic and cultural divides. Their futures will not be the same.

In her ongoing series *Unspoken Conversations* (2014–), the dynamic between mothers and daughters, again in Arab and American contexts, is explored more explicitly: here another chasm is opened up by the photograph – time. The images often depict generational difference as times change, reinforced by the sometimes striking similarities between mother and daughter, their remarkable physical similarity – the blood that binds them – far stronger than the invisible differences time can impose. One of the series's most poignant images, titled *Brigitte and Huguette, Ghazir, Lebanon* (selected for the Taylor Wessing Prize 2015 and displayed that year at the National Portrait Gallery, London), points to another transition: here, the photographer, subjects and viewer are all too aware of the time beyond the passing moment, beyond the photograph that will not be able to preserve it.

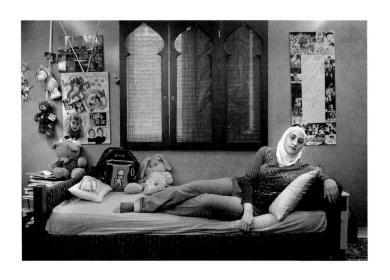

'While the news from the Middle
East tends to focus on our
differences and on "them versus us",
it was important to me to focus
on our sameness ...'

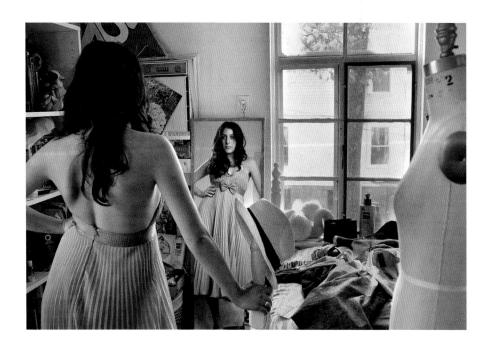

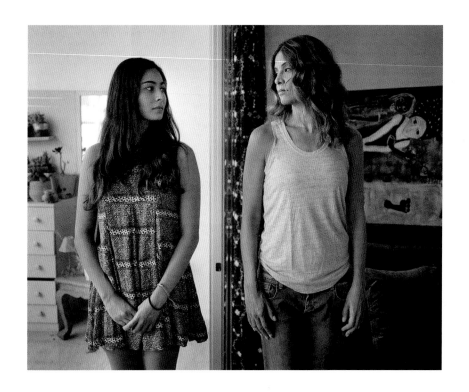

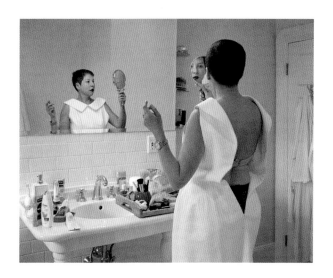

PAGE 34 *Yasmine, 12, Beirut, Lebanon,* 2012
PAGE 35, TOP *Lubna, Beirut, Lebanon,* 2010
PAGE 35, BOTTOM *Zoe, Newton, Massachusetts,* 2009
ABOVE, TOP *Rawiya and Celine, Beirut, Lebanon,* 2015
ABOVE, BOTTOM *Marina, Brookline, Massachusetts,* 2013
OPPOSITE *Brigitte and Huguette, Ghazir, Lebanon,* 2014

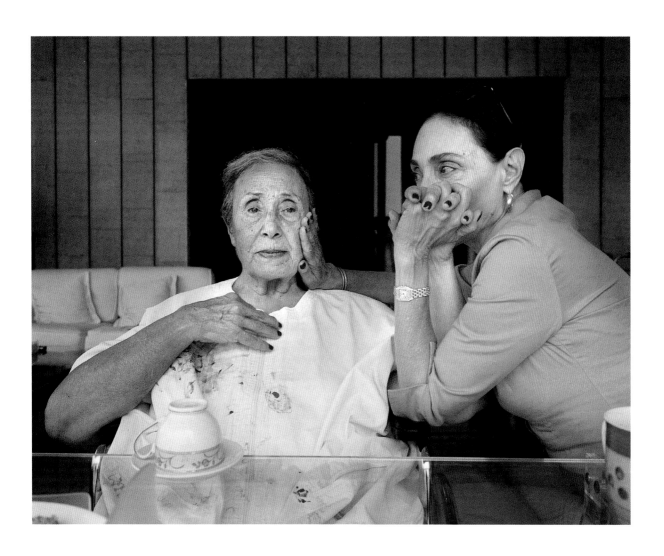

DEANNA TEMPLETON

Documenting female teenhood in California

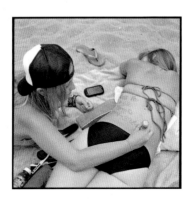

Deanna Templeton has been taking photographs, exclusively on film, since the early 1990s. At first taking pictures was a sporadic teenage hobby, a way to participate: 'I didn't think about galleries or showing them, but I definitely wanted to share my photographs', she tells me. Templeton is still based in Huntington Beach, California, where she grew up. She used a cheap home printer to produce zines of her photographs, giving them out to anyone she could. She still didn't think she was any good, but when her husband – skateboarding legend and photographer Ed Templeton – offered her a small space in a group show he was curating, her prints sold. Over the next two decades Templeton would become one of the foremost female street photographers in the USA.

Templeton has been capturing California's teen subcultures for over 20 years. The influence of her style is visible everywhere. Her archive contains more than 5,000 photographs of women, but it was only when going through her images for a 2016 exhibition that she realized she had a preference for photographing female subjects: 'When I shoot, unlike a lot of street photographers, I don't shoot anything and everything. I have to shoot something because it moves me; I shoot when I feel a connection to something. That's why I press the shutter release.'

Templeton now sees her subjects as unconscious reflections of herself: 'A lot of the young girls remind me of myself when I was young, or how I wish I could have been. There are two different types of women I photograph: the ideal – or what I thought the ideal was – and what I perceived as my reality, which is to say, they are all beautiful. I can say now that I feel good about and totally accept myself, but when I was younger, I couldn't see that, I couldn't appreciate what I had.'

Templeton brings her images together as zines or books in which shifting values and attitudes towards being a woman can be observed, but the persistent focus of her work has been documenting youth scenes on the West Coast, from surfing and skateboarding events to punk shows. In *Scratch Your Name on My Arm*, for example, Templeton spent five years documenting fan girls in southern California: 'When I was younger I was really into music, so I would go to record signings and have musicians sign my records or posters. Now, girls go to events and have signings all over their bodies. It's interesting to explore the differences between what I did and what teenagers are doing now.' In the body of work *What She Said*, Templeton highlights this, juxtaposing pictures she has taken of teenage girls from the past decade with pages from her own angst-ridden teenage diaries, which grapple with body image, self-esteem and sexuality.

Templeton doesn't look at female teenhood with nostalgia or sentimentality but with the empathetic eye of someone who's lived through it and has an urge to empower younger women and inspire confidence – something she's able to do through both her photography and her direct encounters with her subjects on the street: 'I remember asking a group of young girls for their permission to shoot them for a project, and I noticed that men were trying to shoot their butts. As I was looking at them through my lens, I thought, they don't know they have the power to say no. I do feel a responsibility – personally – and I know other female photographers who feel differently, but if I have the opportunity I'd rather not contribute to that mistake.'

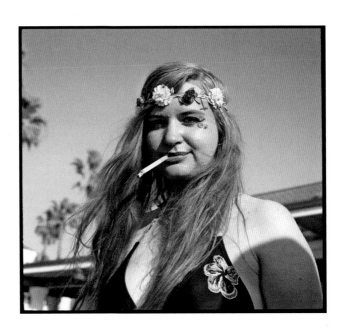

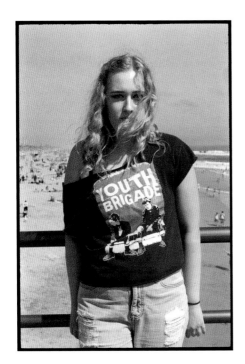

'A lot of the young girls remind me of myself when I was young, or how I wish I could have been.'

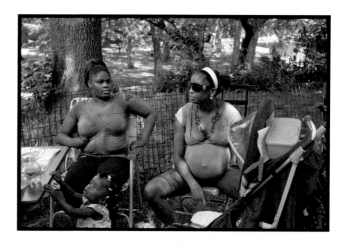

PAGE 38 *'Call for a Good Time', Huntington Beach CA*, 2012
PAGE 39, TOP *'Flowers in Her Hair', Huntington Beach CA*, 2016
PAGE 39, BOTTOM LEFT *'Youth Brigade', Huntington Beach CA*, 2016
PAGE 39, BOTTOM RIGHT *'Coral', Huntington Beach CA*, 2013
ABOVE, TOP *'Sandi', Huntington Beach CA*, 2015
ABOVE, BOTTOM LEFT *'Leopard Print', Huntington Beach CA*, 2016
ABOVE, BOTTOM RIGHT *New York NY*, 2011
OPPOSITE *'Mary', Huntington Beach CA*, 2015

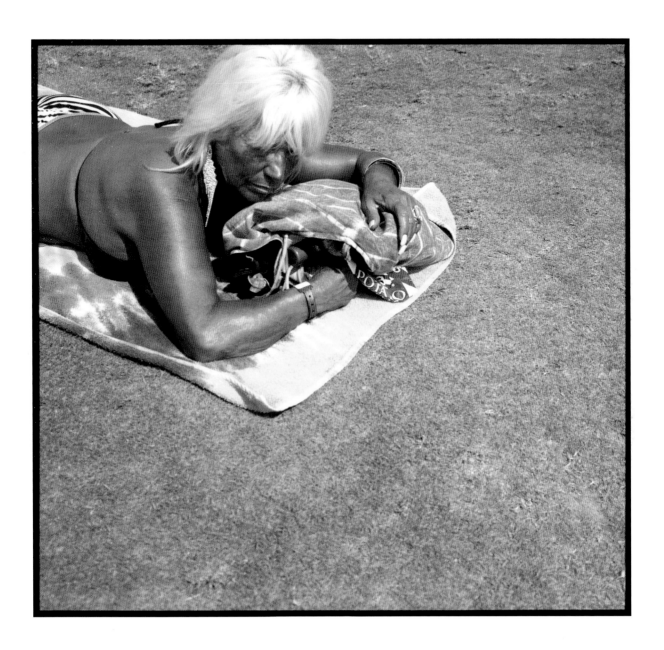

LILIA LI-MI-YAN

Beauty masks

'There is a certain stage in your life when social appreciation is crucial for building your self-acceptance. Every woman at some point has to face the question of beauty (and standards). I often imagine myself in my model's place: how would I feel? How do they feel in front of a camera?'

Lilia Li-Mi-Yan's work examines different perspectives on beauty and the functions of beautification in contemporary culture through the interconnected relationships women experience between image and reality, a mask and a face, the artificial and the natural. In her 2013 series *Masks*, for example, diptychs of women photographed with and without their make-up, Li-Mi-Yan seems to ask the viewer to make a direct judgement: which version is better, natural or made-up? As she spent time with her subjects, the photographer understood that each woman has her own reason for applying make-up. Her questioning shifts: which is more 'real'? A mask is as much a projection of a woman's individual identity as the 'real' face underneath: 'Many women want to see themselves as young and irresistible – they don't mind the gap between the image and reality. They feel ok about self-delusion.'

Similarly, in her series *Female Prison* (2013), portraits Li-Mi-Yan took of inmates at Armenia's only women's prison, it becomes clear that applying make-up is part of a self-care ritual that helps these women maintain a sense of feminity and normality. Li-Mi-Yan implicates the camera and its role in producing 'exemplary' standards for women.

Both the industrial and the personal camera have developed technologically and contribute to a fixed visual definition of beauty. Photography has also given us the idea that, with the right light and the right angle, everyone can fit this mould of beauty. The same ideas are sold to women by the cosmetics industry: 'I'm for realism and consciousness. I am concerned about the fact that many women still compare their appearance with the idyllic images that mass media and advertising produce.' Li-Mi-Yan sees this as a social issue that goes far beyond the women we encounter in her photographs: 'Your body is constantly assessed by society. But you could use this as a playful moment as well – to play a bit of hide and seek through changing different masks. I'm interested in exploring how the way we communicate is modified when a person uses a variety of masks.'

If we accept the right to modify our bodies, how can we challenge the reasons for doing so? Women continue to adapt themselves to fit social ideals, even when these ideals change and diversify. Simply replacing one ideal with an alternative, or alternatives, is not enough. Photography for Li-Mi-Yan is a way of discussing the conflicts and contradictions in our systems, but she avoids photographing women in order to set new standards for women: 'I do believe that these issues naturally concern me more as a woman. I confront these questions and try to reflect upon them and find the answers for myself. I think we all deal with the same sort of problems, more or less, and presenting different views and opinions helps to get a better understanding of it.'

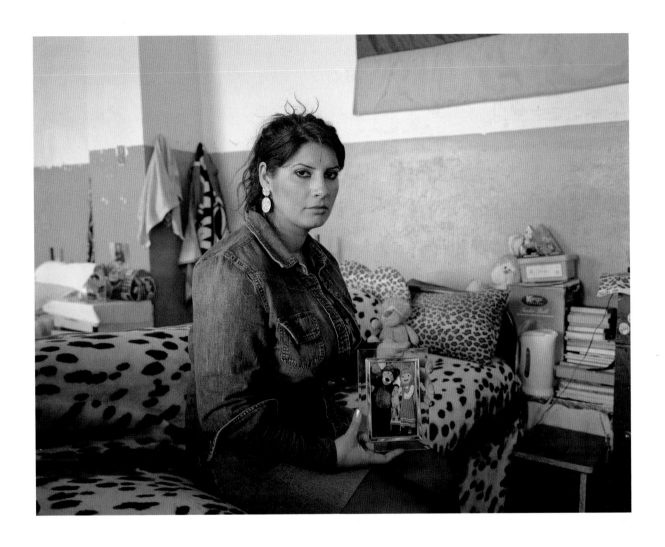

'Many women want to see
themselves as young
and irresistible – they don't
mind the gap between the
image and reality. They feel
ok about self-delusion.'

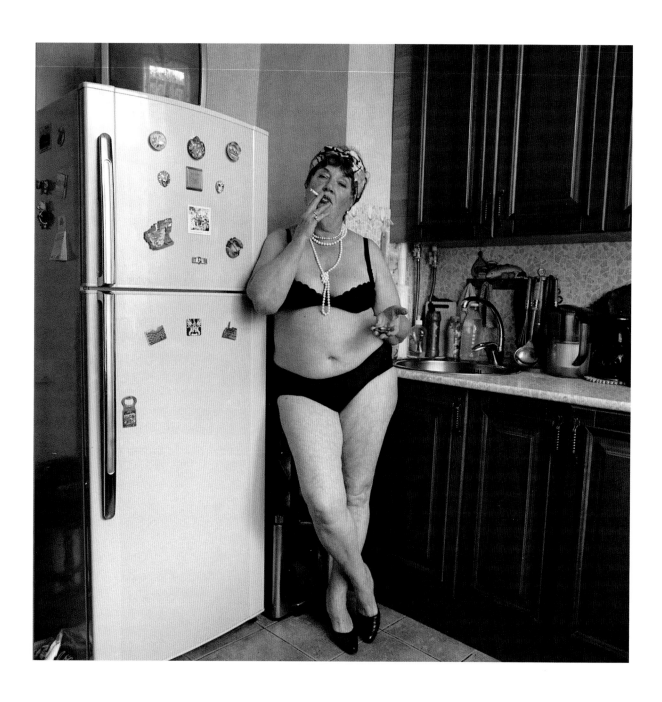

PAGE 42 From *Fake*, 2014
PAGE 43 From *Female Prison*, 2013
ABOVE & OPPOSITE From *Mature Beauty*, 2013

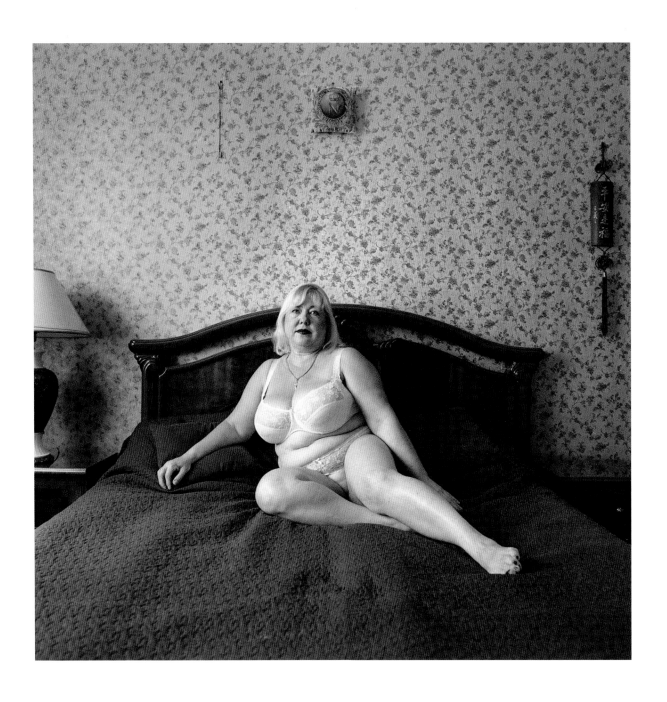

MIHAELA NOROC

The atlas of beauty

Three years ago, photographer Mihaela Noroc left her native Romania with a backpack and a mission: to photograph women in every country in the world. To date, she has taken portraits of women in more than 50 countries – an unprecedented visual record of female beauty by a woman.

Noroc's initial aim was to explore the world's diversity through women, but she has also encountered the things that women share when they are in front of her camera: 'My project encourages and celebrates the diversity of the world, so I'm always searching for diversity, but at the same time I noticed that there is something that is common to all women that I photograph: it's a feeling of honesty and serenity that comes from the eyes.' Noroc's idea of beauty, as she points out, is personal. While many Western photographers have exoticized and eroticized the beauty of women in far-flung lands, Noroc's survey – hard not to find compelling – approaches women from a female perspective. From waitresses in North Korea to ice hockey players in Bulgaria, market sellers in Tajikistan and a woman on her way to the hospital to give birth in China, or pilgrims and policewomen in India, the realities of Noroc's women are as various as their beauty. Her physiognomy defies the stereotypes of cultural beauty inherited from anthropological photography and mass media over the last century and a half.

As a Westerner and an outsider, the criticism her portraits invite is unavoidable. The lengthy debates they spark beneath her posts on her social media, on the position of women in different societies around the world, widen the parameters for interacting with her images: her audiences are her most incisive critics. While her work is openly a visual examination of physical appearance, Noroc's impulse is instinctively pro-women – and, I realized in my exchanges with her, without cynicism. 'If we refer to women, many of us feel pressure to look a certain way, almost everywhere in the world. In conservative countries the pressure is to look more conservative, in liberal countries the pressure is to look very trendy and sexy, because otherwise you might not be considered beautiful', Noroc tells me. 'I think every woman should choose for herself. Being yourself should be something that is normal, not an exception.'

As a female photographer, her access to the women she shoots around the world is also different, most of the time. 'I had days when I approached dozens of women on the street and they all said no', Noroc explains. 'The fact that I'm a woman offers me the opportunity to look into a mirror every time I photograph another woman. I talk with her, I understand her struggles and dreams and in this way I also get to know myself better.'

Disseminated mainly through accounts on Facebook, Instagram and Tumblr, and soon to be published as a book, Noroc's images are accompanied by detailed captions, a personal account of the cultural discoveries she makes through photographing women: 'For me this project is a way to discover the world, but also to discover myself, as a woman.' She continues, 'I try to show that it's great to be ourselves but at the same time it's great to let other people be themselves. I really hope that people feel that when they see my photos.'

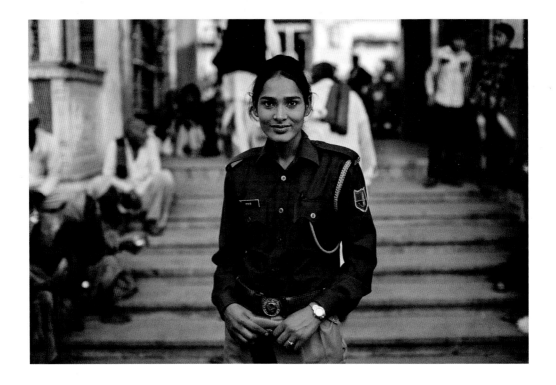

'I noticed that there is something
that is common to all women
that I photograph: it's a feeling
of honesty and serenity that
comes from the eyes.'

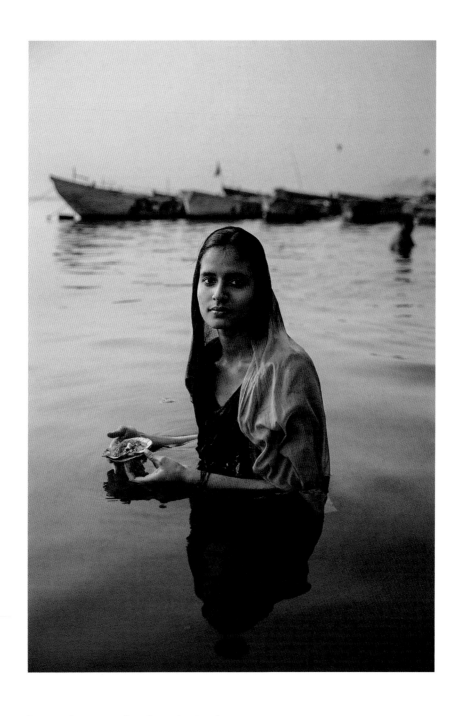

PAGE 46 *Mother and son on the streets of Kathmandu, Nepal*, 2015
PAGE 47, TOP *Kichwa, Amazon Rainforest*, 2014
PAGE 47, BOTTOM *Policewoman in Pushkar, India*, 2015
ABOVE *Hindu pilgrim, Varanasi, India*, 2015
OPPOSITE *Wakhan Corridor, Afghanistan*, 2015

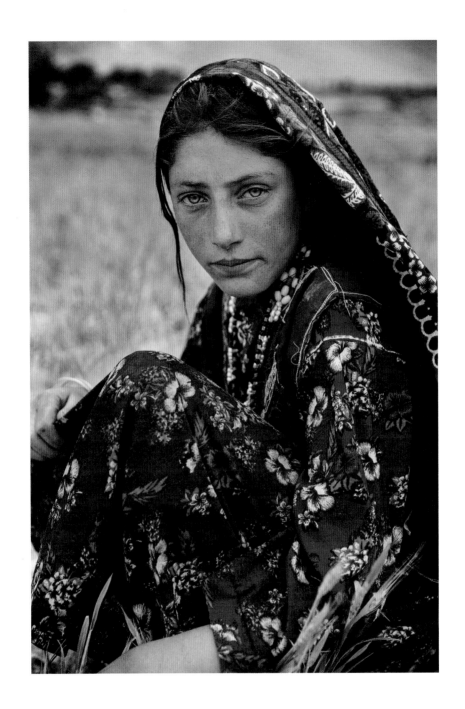

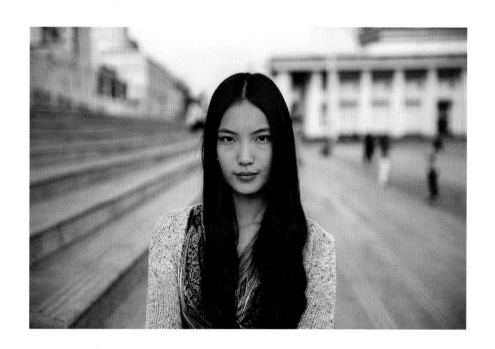

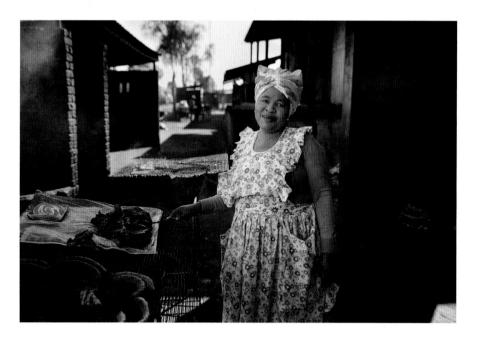

ABOVE, TOP *Ulaanbaatar, Mongolia,* 2015
ABOVE, BOTTOM *Cape Town, South Africa,* 2016
OPPOSITE, TOP *Melina in Shiraz, Iran,* 2013
OPPOSITE, BOTTOM *Tibetan woman in Sichuan Province, China,* 2015

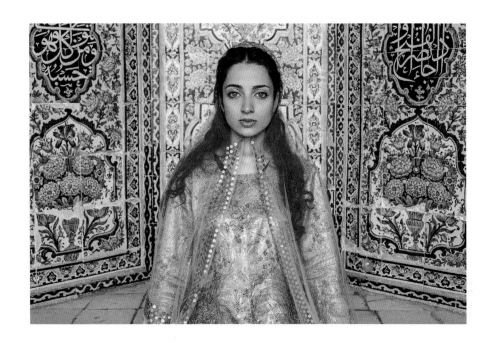

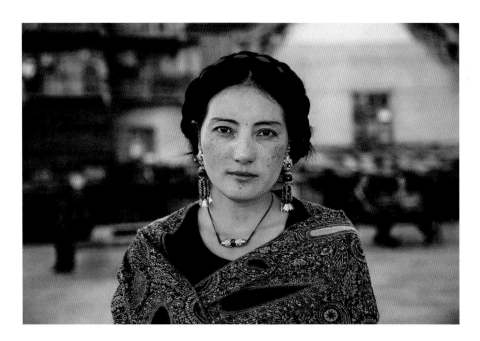

IIU SUSIRAJA

Photographing the body with an uneasy humour

Iiu Susiraja stares at us with a blank expression. She is looking directly at her camera but also at her viewer, and at herself. The artist has been photographing herself posing in disaffected domestic scenes since 2007: 'I do not think about my body when making art. The more you take self-portraits, and see your own self-portraits, the more the body becomes familiar. I do not find it difficult to look at my own body in my self-portraits. In the first self-portraits (in July 2007) I had a hard time looking at myself, but the difficulty of watching myself passed very soon.'

Susiraja's placid stare could also be interpreted as a challenge: should we laugh? If we laugh, what are we laughing at? Her body is not the type of body we encounter regularly in photographs and she invites us to laugh at the way she manipulates it. But the everyday household items she uses as prosthetics also read as an auto-critique of her body – scissors held over the lips, a broom propping up her boobs – and of the viewer's expectations of a body. Is this what I want? Is this what *you* want?, she seems to ask. Like the consumer products she wields and toys with, we're unsure as to whether the domestic setting, the archetypal domain of femininity, stifles or protects her. All the contradictions in the way we look at our own bodies and others' bodies, mediated through images, meet in her photographs. Their humour is not easy.

Susiraja suggests the viewer looks where she is looking, but her deadpan gaze does not allow us to feel what she is feeling. It creates an ambiguous, uncertain viewing experience: 'The camera shows the body more directly: it is usually a different image from the state of mind we find ourselves in. The camera is even more direct than the mirror. The camera does not forgive, but it is not necessarily a bad thing. In fact, I like the openness and honesty.'

Yet the assumed 'honesty' of the camera – in the sacrum of the home, alone and in private – is also ambiguous. The camera is manipulative. In Susiraja's work, she portrays herself, but the camera allows her to act differently, to produce actions that might not otherwise have happened. The camera is a confirmation of these planned performance acts, and she can control, frame and articulate her image to express what she wants the viewer – whether herself or the unknown public – to see.

The reactions from that unknown public are not always encouraging. Once she received an email from an anonymous viewer. It said, 'Go and get a proper job.'

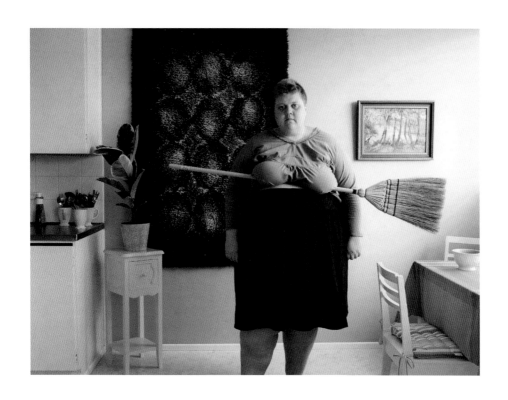

'The camera is even more direct than the mirror. The camera does not forgive, but it is not necessarily a bad thing. In fact, I like the openness and honesty.'

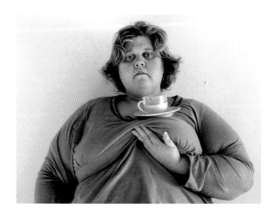

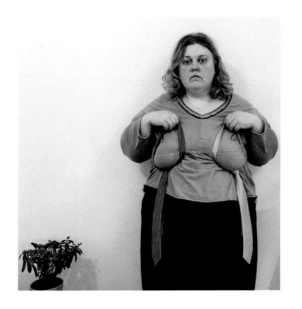

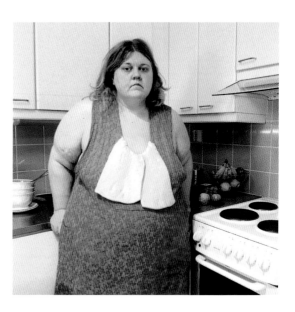

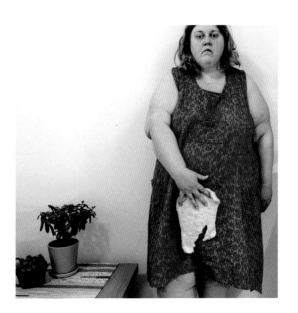

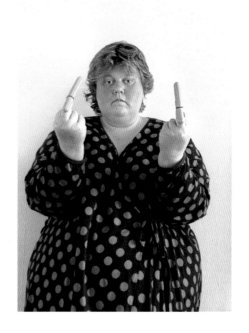

PAGE 52; PAGE 53, BOTTOM; ABOVE, BOTTOM RIGHT; & OPPOSITE From *Tuhmaa pullaa/Naughty buns*, 2011–12
PAGE 53, TOP From *Hyvä Kaytos/Decorum*, 2008–10
ABOVE, TOP LEFT & RIGHT, & BOTTOM LEFT From *Täydellinen arki/Perfect for everyday*, 2012–13

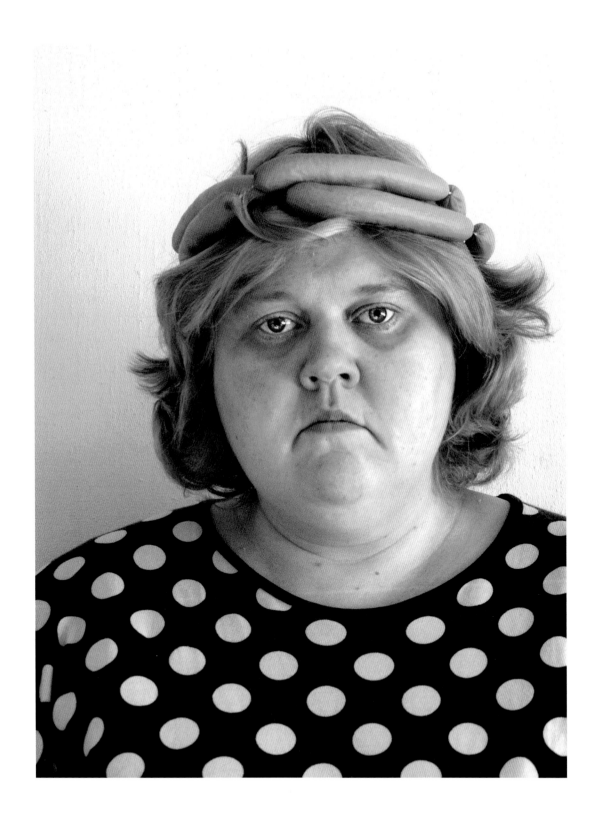

TONJE BØE BIRKELAND

Women wanderers

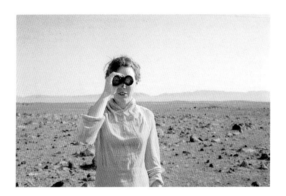

'The romantic motives of the male wanderer have been well documented and well portrayed in art history – see, for example, *Wanderer above the Sea of Fog* (1818), painted by Caspar David Friedrich', Tonje Bøe Birkeland writes of her project *The Characters*, started in 2008, in which the artist stages the expeditions of female explorers presented as large-format photographs together with written journals. 'In my project the characters are female. The heroine moves in pristine territory: in front of her looms grand exploration; beneath her, history is formed. But in spite of grand vistas and sublime experiences, expeditions come at a price, both in posterity and today.'

Birkeland sees her project as feminist – and as a necessity, since female polar explorers and adventurers in the past (she is particularly interested in the period between the First and Second World Wars) have been demarcated in documentation by their gender first, rather than by their achievements. With the fastidiously detailed photographic and written documents she presents, Birkeland makes up for this lack in the archive and establishes the female position in history. Whether her characters existed or are invented – or both – is deliberately ambiguous, but trying to establish truth from fiction would be a diversion. Birkeland is interested instead in raising the question to examine how we see a woman before we see anything else. Birkeland's feminism intersects with other concerns, such as 'the West's need to control and colonize. With the exploration of new land – new resources – power follows. As we seek adventure, we partake in the transformation of nature into landscape. The journey becomes a part of our collective history.'

Photography continues to play a significant role in conquering the unknown; a photograph can be used as a proof of presence, of an experience, where the unknown is reduced to an object that can be categorized and shared as knowledge. There's a romanticism in landscape photographs that is paralleled by classical depictions of women. Birkeland finds both these representations problematic. She reverses the colonial function of the photograph as a proof of power; her images are a visualization of absence – gaps in stories that have been told, and gaps in our understanding of nature.

Each of Birkeland's photographs also contains its own meta-journey, the real journey of the female artist herself. Birkeland travelled to Greenland, Mongolia, Bhutan and the mountains of Norway to shoot her photographs and, in doing so, establishes her own narrative with her character: 'Each project leads closer to the objective of a gallery of personas of female heroines from the past, who through narrative, fantasy and photography can fill a void in our history and reveal contemporary society's challenges: globalized colonization on the one hand and the loss of the great adventure on the other.'

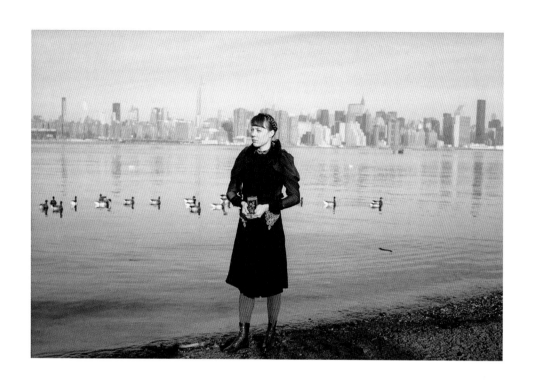

'Each project leads closer to
the objective of a gallery of personas
of female heroines from the past ...'

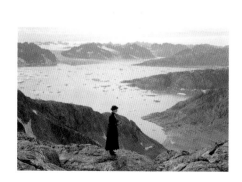

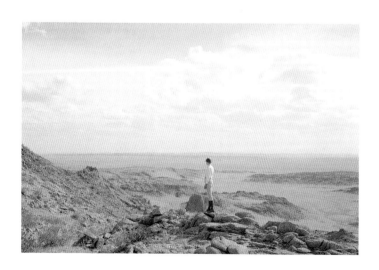

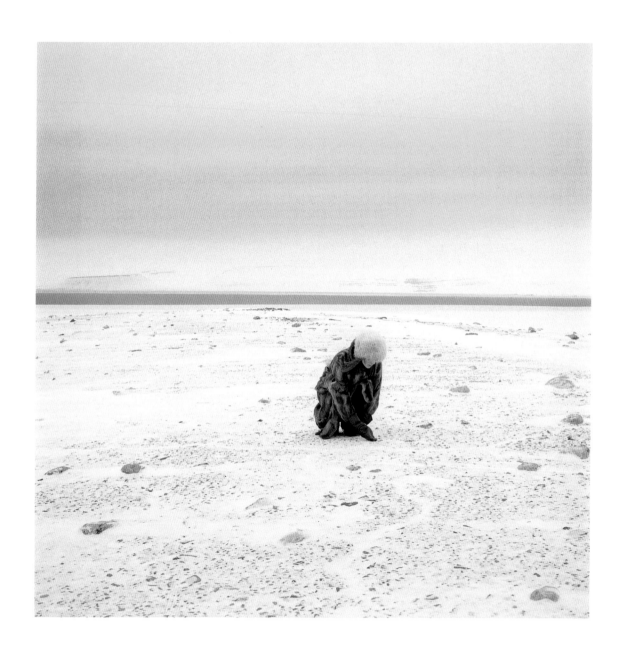

PAGE 56 *Gobi 1931*, 2012 (*Character #II Tuva Tengel 1901–1985*)
PAGE 57, TOP *First Street, Town of Williamsburg*, 2013 (*Character #III Luelle Magdalon Lumiére 1873–1973*)
PAGE 57, BOTTOM LEFT *Across from Kangerdlugssuaq*, 2015 (*Character #IV Anna Aurora Astrup 1870–1968*)
PAGE 57, BOTTOM RIGHT *Baga Gazryn Chuluu 1929*, 2012 (*Character #II Tuva Tengel 1901–1985*)
ABOVE *Tempelfjord*, 2009 (*Character #I Aline Victoria Birkeland 1870–1952*)
OPPOSITE, TOP *Southern Gobi 1928*, 2012 (*Character #II Tuva Tengel 1901–1985*)
OPPOSITE, BOTTOM *Kangerdlugssuaq*, 2015 (*Character #IV Anna Aurora Astrup 1870–1968*)

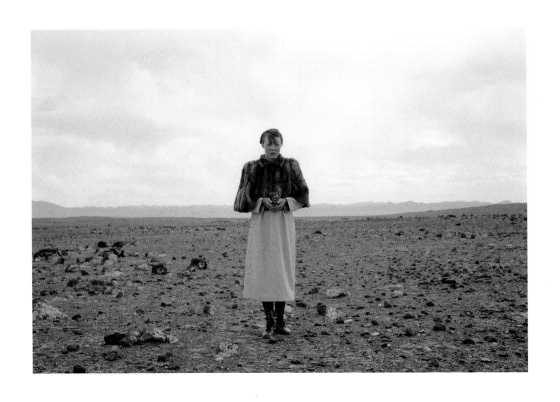

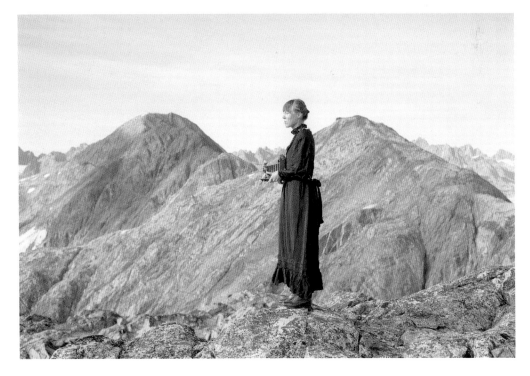

BIRTHE PIONTEK

The instability of a photograph

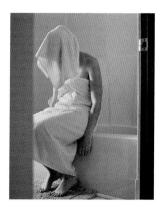

When Birthe Piontek takes a portrait, she feels an intimate bond with her subject: 'It's always a bit like falling in love with a person, regardless of gender or age. There is a bit of "flirting" – from both sides, the photographer and the subject.' When she photographs women, she notes, 'there can be a different level of kinship or trust when taking pictures of a woman. Maybe I can read or understand little signs and gestures better – if there is some nervousness or awareness regarding their appearance. I know what it's like being a woman and I can relate and understand in a different way than a man.'

The affinity Piontek feels with her female subjects goes beyond the interaction during the shoot: 'Maybe female subjects are, to a certain degree, "stand-ins" for myself; through them I can express my internal landscape and the kind of feelings I am experiencing.' Her photographs are attempts to visualize the invisible internal self through her lens. This is the premise for an exchange that takes place between the photographer and her subject: 'Although I am trying to understand and convey the complexity of my subject's identity, I am also aware of the limitations of my medium and, most importantly, that the person in front of the camera also always reflects the person behind it.'

The concept of self and its relationship to the camera is addressed further through her own body, in the self-portrait series *Lying Still*. Piontek juxtaposes her image with still lifes and found press images of women from the 1950s and 1960s to forge links between the past and present, the animate and inanimate. What the camera expresses in the photograph is only a projection of what we can discern with the eye. 'In this series I use my body as a catalyst,

a tool to express themes of intimacy and mortality and to address the desires, urges and fears that exist latently in our subconscious. The images refer to our dreams, to something unknown, an inner landscape of our minds that is hard to point out or put a finger on.' In the series *Mimesis*, Piontek deepens her study of our relationship with images and the unseeable. She photographs sculptures made of found photographs and other materials that play with reflection (glass, ink) to reveal through process the layers of distortion present in a photographic image, refracted and altered by the artist's hand, light, lens and mirrors.

In a chaotic image world, Piontek tries to establish her own narrative. The impulse to define our experiences with photographs is insatiable: 'We are drawn to our images in the mirror, our reflections in a window, we put up pictures of ourselves or loved ones on the wall … It seems we've always tried to capture the essence of our identity. Photography taps into this very human desire.' In an anxious age where access to so much information produces an unstable and insecure perspective of reality, photographs are a coping strategy rather than an answer: 'I don't think that taking all those images of ourselves makes us understand the complexity and, for the lack of a better word, strangeness of our being in the world any better.' As a photographer, Piontek is conscious of her role in this: 'Maybe some people find it helpful to look at my images, maybe it helps them navigate or see things differently but I don't know if, by producing images, I actually help people navigate the flood of images or if I am just adding to the stream.'

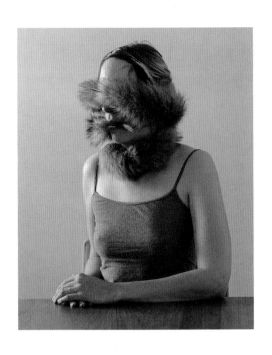

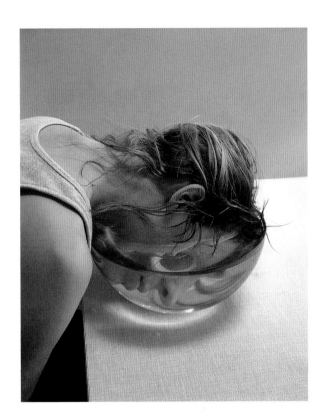

'There can be a different level
of kinship or trust when taking
pictures of a woman.'

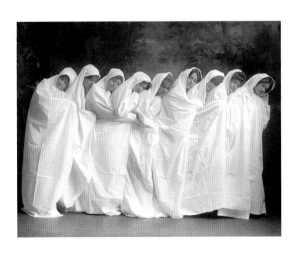

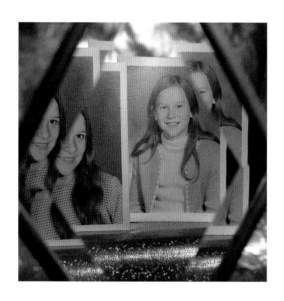

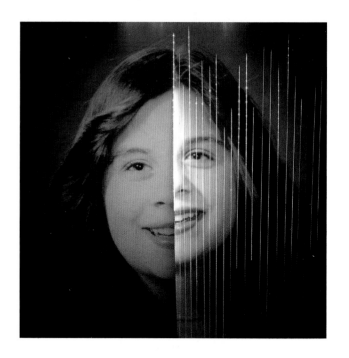

PAGES 60 & 61, & OPPOSITE All from *Lying Still*, 2010–16
ABOVE Both from *Mimesis*, 2012–14

JAIMIE WARREN

Self-portraits as other people

Inspired by 15 years of punk shows, drag shows, theatre, comedy, 1980s American TV and the unlikely 'shero', Jaimie Warren's performance-photography turns her body into a medium, a canvas for a cast of colourful characters: 'I think I am hoping that I can create work that is substantial and thoughtful in its own way, and could simultaneously make someone laugh or feel good. I want my passion for the characters I am creating to really shine through, and for that to be the most important factor in the work.' In her first self-portrait, *Self-portrait as Kali Conner* (2012), Warren paid homage to comedian Roseanne Barr, who was an indelible influence on the artist growing up. Warren sees her as a woman who succeeded against all the odds in a man's world. The way Barr used humour with attitude resonated most with Warren, and remains at the core of her artistic practice: 'She was a true underdog and an inspiration, making such a hilarious and touching and meaningful show, exhibiting such heartfelt struggles of the lower-middle class. It hit home for so many people, including myself, mostly because my own mother and Roseanne were so similar in their sarcastic feminist humour, attitude and work ethic.'

Warren's body – American, white, female – is not seen in a way that we recognize. There isn't such a thing as 'the body' in her work, and her photographs don't even give the viewer her body: 'I guess whenever I am making these images, I am never really thinking of myself as a woman doing these sets and costumes and poses and such. I feel like more of a weird motley character attempting all these different roles, and my focus is always on portraying the mood and facial expression and very specific sense of

humour I am going for. I feel more like a living cartoon, or an overgrown child, than a woman, and my daily life sort of reflects that as well.'

Warren makes all her sets, costumes and props by hand, part of a stage she designs to perform a spectacle of the self. In the making of her self-portraits, gaudy and hilarious, we experience the vertigo of identities constructed through images, adding interpretation on interpretation. In the series *Celebrities As Food* and *Food'Lebrities*, for example, Warren portrays herself as other people based on pictures of celebrity food puns she finds: 'I was really interested in recreating pre-existing images and sort of putting my own spin on them and forming them into self-portraits.'

Though Warren isn't fazed by the politics of putting her body in her images, she does explore the way identity is shaped by the absurd cult of celebrity, entertainment and sensationalism, through the proliferation of images in mass media. It is not a straight critique, but by deconstructing the language of pop entertainment, she explores its surreal, humorous and extraordinary attributes, and how they might manifest in an extravagant, polymorphous self-image: 'I guess I see myself, or my body, as this weird object I can use as a tool. Of course the most important component is always my expression and the type of humour I am trying to create, but I see myself more as this mass, this character. I think I am forever trying to emulate Marjorie the trash heap from *Fraggle Rock*: "I'm orange peels, I'm coffee grounds, I'm wisdom!" Gross and matronly and magnificent.'

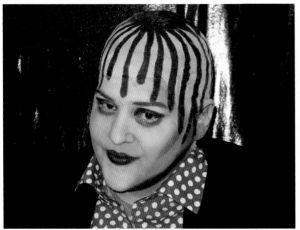
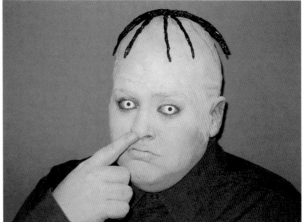

'I feel more like a living cartoon,
or an overgrown child,
than a woman, and my daily life
sort of reflects that as well.'

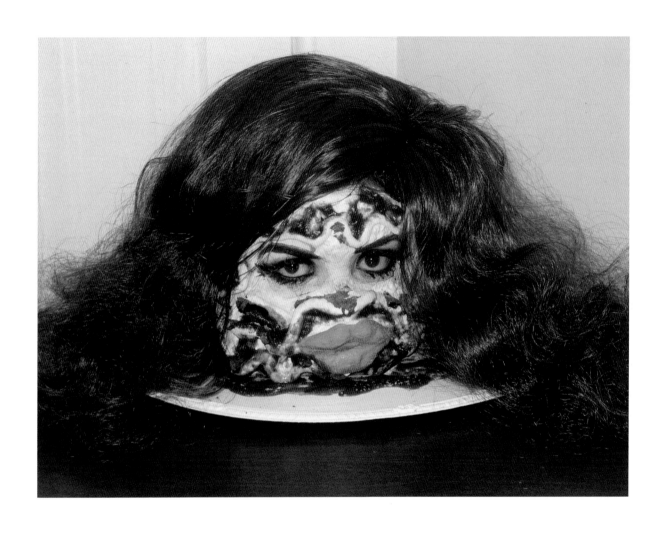

PAGE 64 *Self-portrait as JonBeignet Ramsey* (from *Celebrities as Food*), 2012
PAGE 65, TOP *Female Gremlin Totally Looks Like Lil' Kim* (from *Totally Looks Like*), 2012
PAGE 65, BOTTOM *Boy George Totally Looks Like Ralph Wiggum* (from *Totally Looks Like*), 2014
ABOVE *Self-portrait as Lasagna Del Rey* (from *Celebrities as Food*), 2012
OPPOSITE *Self-portrait as woman in Les Demoiselles d'Avignon by Pablo Picasso* (from *Art History*), 2012

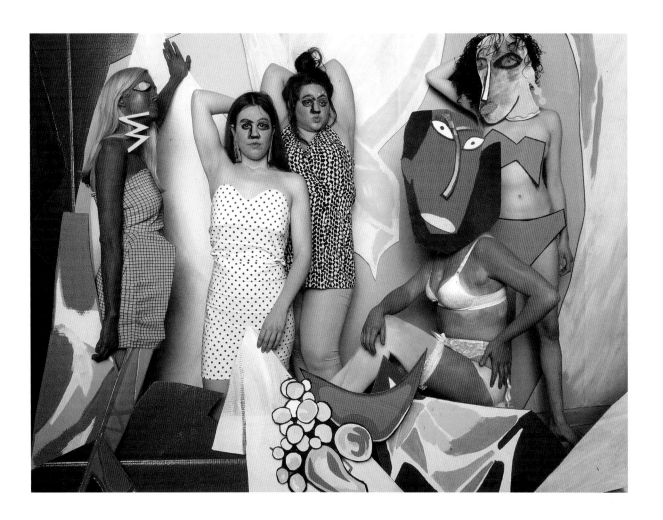

MAISIE COUSINS

What girls are really made of

Maisie Cousins didn't get on very well with the education system. At school, and later at university in the UK, her teachers weren't too encouraging of the kind of photography she was doing. Meanwhile, Cousins was creating her own URL universe with thousands of followers around the world who did support her work. It gave her strength, and was an escape route. 'I'd probably be a vandal if I hadn't had Instagram', she tells me, sitting at her kitchen table in East London. When she talks about her experiences at school, only a couple of years ago, it's clear that we still have limited ideas about what female photography is and could be. But then, photography has always been the most problematic art form – add naked women, and it's a can exploding with worms.

Cousins is aware of the mould the media want to cast her and her work in: still only in her early twenties, she's constantly being asked about her politics: 'Boys don't get asked the same questions about their work.' This doesn't mean she's afraid to speak out or that she's anti-women – only that she is justifiably weary of new feminist art clichés and suspicious of who is profiting from them. Hashtag definitions don't do her work justice.

Photography-based platforms like Instagram and Tumblr were first and foremost a way of getting through teenhood for Cousins. But they also gave her a creative space where schooling had failed, a place to experiment with the few resources available to her: her models were friends, and other people who were willing to do some strange things in front of her camera for free. Cousins's photography has evolved through her audience: the direct interaction with her community online has served as her work's critique.

Cousins's work addresses the clichéd depictions in art of bodies and femininity through textures, symbols and the senses: you can almost smell her images. She shows me vintage food magazines that inspire her. 'Phwoar, look at that!', she says, pointing out a plate of quivering gelatinous jelly. Each of her photographs is an assemblage of matter and scents, digital installations that are sticky, gloopy and liquidy, metaphors for the real things a body goes through.

One of Cousins's most popular images – from the series *Grass, Peonie, Bum* – is of a young woman grabbing a handful of her own wet, tumescent bottom, which is spattered with grass and petals. Both glossy and grubby, it is not your standard bum shot. In more recent works, Cousins pushes her visual metaphors further by removing female bodies from the image altogether, using things that traditionally signify wholesome, clean, archetypal femininity – flowers and fruit – but mixing them with live slugs and snails, safety pins, syrupy red liquids and dark, mucousy substances that tell a different story of the female body. Making these image-analogies is also a way for the artist to talk about bodies without the guilty feeling that she says creeps in when she photographs naked women and has control of the image.

Cousins deals with sensory contradictions in the digital consumer age, and the way we are exposed in quick proximity to images that arouse, disgust, seduce and repel. Cousins shows us that this is *What Girls Are Made Of* – as the artist titles one series of works, where pomegranates and flowers are sensual feminine vessels, but with shrimps floating in their midst.

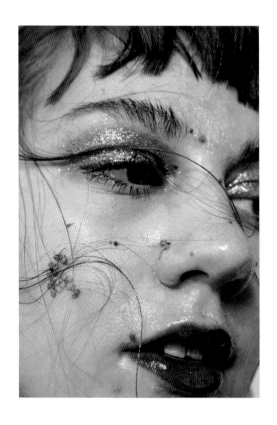

'Boys don't get asked the same
questions about their work.'

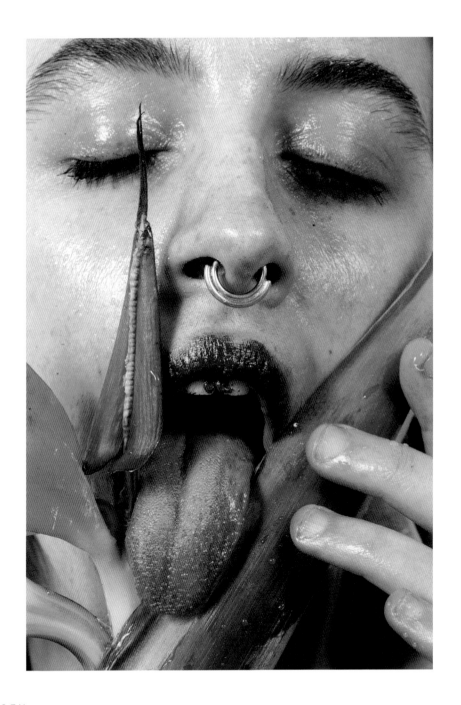

PAGE 68 From *S.E.X.*, 2015
PAGE 69, TOP LEFT *Celia*, 2015
PAGE 69, TOP RIGHT *Orchid*, 2016
PAGE 69, BOTTOM Untitled, 2015
ABOVE *Molly*, 2016
OPPOSITE From *Grass, Peonie, Bum*, 2015

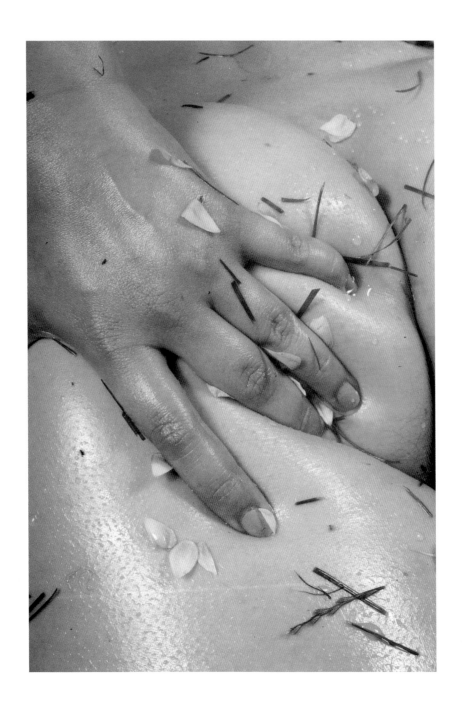

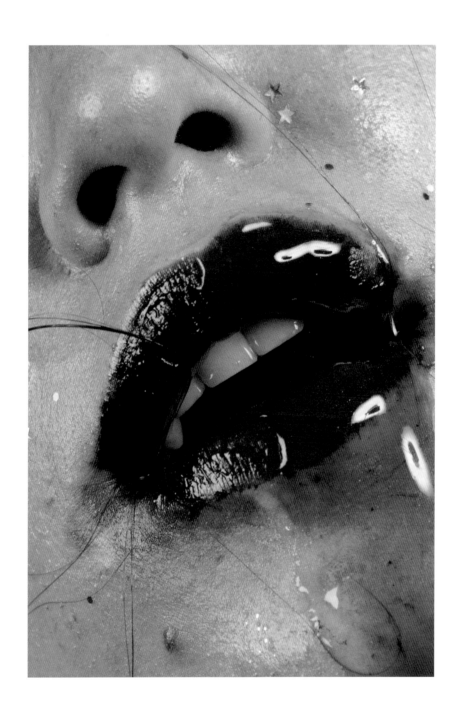

ABOVE *Sticky Lips* (from *S.E.X.*), 2015
OPPOSITE From *What Girls Are Made Of*, 2015

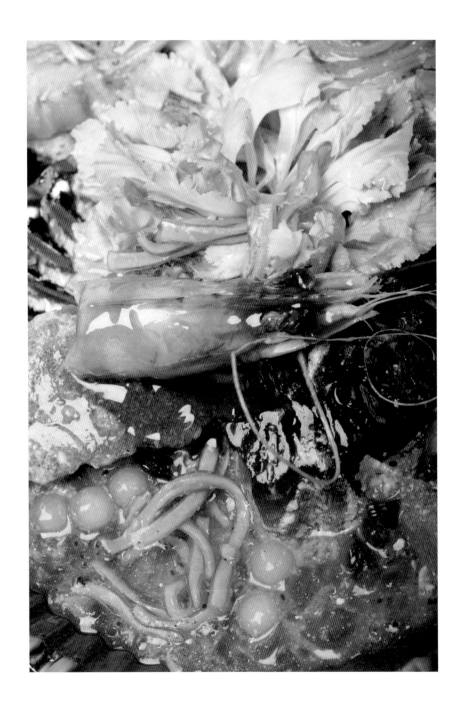

ISABELLE WENZEL

Autotimer, camera, action

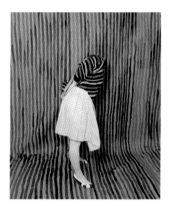

'I was stressed by the idea of the photographer as someone who goes out and explores the world. I didn't want to explore the world', Isabelle Wenzel tells me. 'I liked images of people, but I didn't like the social interaction that came with photographing people: making small talk, taking care that the model feels good, being focused and behaving in a socially smart way at the same time. And I couldn't stop thinking about the outcome as something I wanted, in a way, betraying the model's needs.' In 2011 Wenzel decided to stop photographing other people and become photographer, model and performer. It allowed her to explore her strong aesthetic interests and create her own world, without the social discomfort.

A photograph often says more about the current way of viewing things than the people in front of, or behind, the lens. Wenzel stimulates situations for looking at bodies, but her face never appears: 'The thing with gender is, even if you don't want to talk about it, we talk about it all the time. So if I'm performing, people can't ignore the fact that I'm a female performer; this is the first thing they interpret. So what they see is a female body performing and with this come all the clichés we have in mind about femininity. I'm not interested in feminism or femininity. My images are not about a specific person, or individuality. I do use my own body as a form in order to say something general about physical being: I'm interested in how we look at the human body in general and its mediation.'

Working against the pressure of the autotimer, Wenzel's performance-photographs involve dashing out into the space she has created for the image and assuming an instinctive, spontaneous pose within it. She repeats the process until she captures the perfect posture: 'My body organically knows what to do, in a way that the camera becomes almost like an extension of it, a synthesis of man and machine. My actions and images are infinite loops with small variations. It is like moving in circles, sometimes it's a nightmare and sometimes it's pure fortune.'

The resulting photographs are documents of a deliberate, improvised action that tests the polymorphous sensuality of the body. John Berger writes in his essay 'The Ambiguity of the Photograph', 'when we find a photograph meaningful we are lending it a past and a future'. Wenzel's allusive and elusive images encourage the viewer to complete the story.

Wenzel's photographs are also concerned with physical contradictions: inanimate objects and inert spaces are activated by the unexpected dance of a pair of legs. 'I use the legs as I see them as an opposite to the brain. They are impulsive, dynamic, organic and animalistic.' The body becomes form and form becomes the body: 'I'm often inspired by questions, sentences, or by the imagination of a feeling. Like hitting the ground, it hurts a lot but still you can't stop laughing about it. Or the question: what does a kitchen table feel like? What kind of person would a piece of furniture be? I love furniture, it has a personality, it's sexy, but then it's also just an inanimate thing. Patterns and textures inspire me; they give me a certain feeling or state of mind too.'

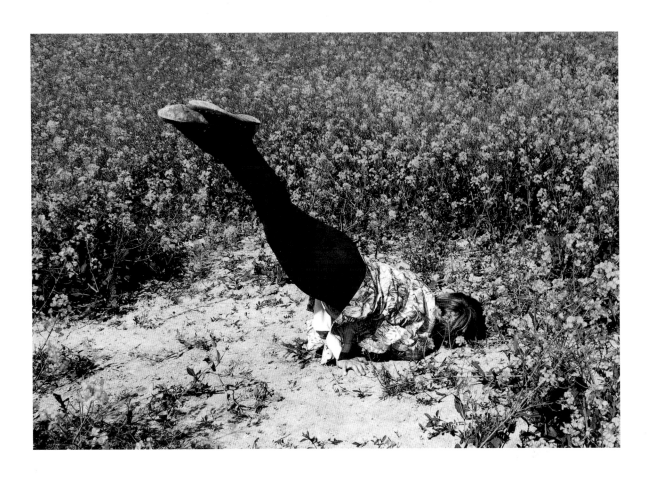

'My body organically knows what to do, in a way that the camera becomes almost like an extension of it, a synthesis of man and machine.'

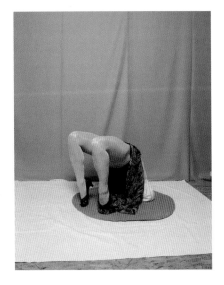

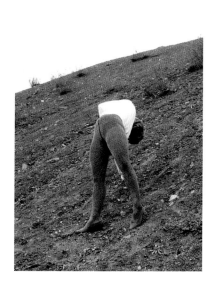

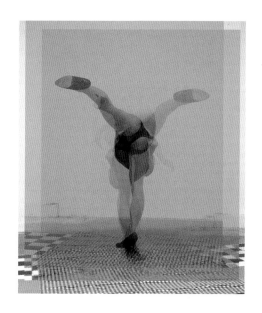

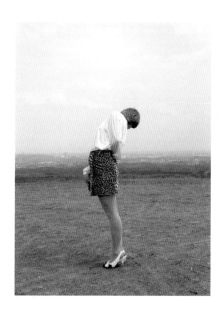

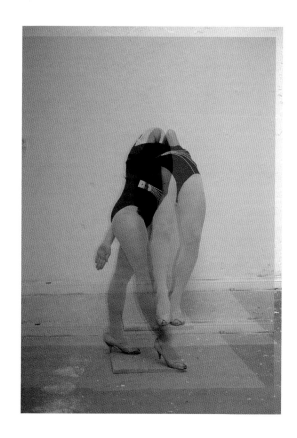

PAGE 74 *Strips 6.1.1*, 2015
PAGE 75, TOP *Field 1*, 2015
PAGE 75, BOTTOM *Rotation 2*, 2014
ABOVE, TOP LEFT *Halde 2*, 2014
ABOVE, TOP RIGHT *Double 4.2*, 2016
ABOVE, BOTTOM LEFT *Field Studies 1*, 2014
ABOVE, BOTTOM RIGHT *Double 5*, 2016
OPPOSITE *Red, Yellow, Blue*, 2015

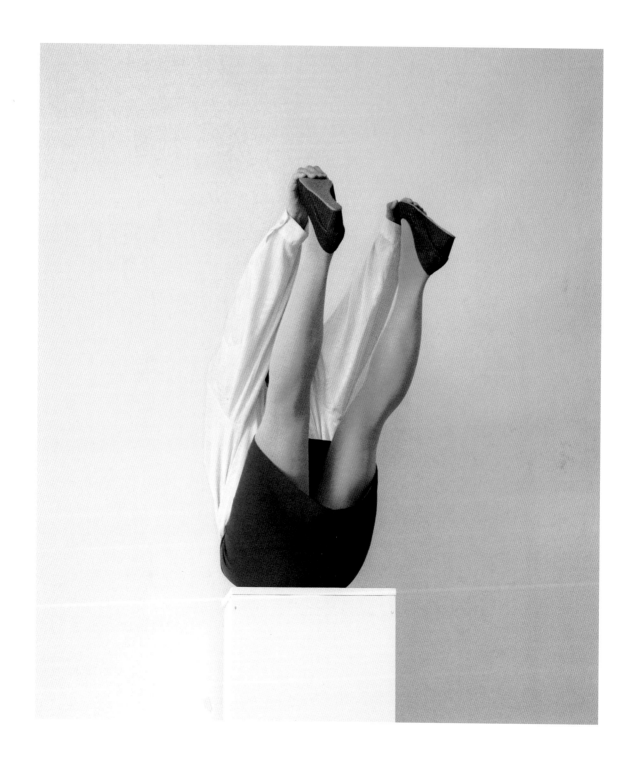

PINAR YOLAÇAN

Changing the way the camera treats a body

Over the course of history, the camera has had an ongoing relationship with sociological study. Common early uses of photography, in the late 18th and early 19th century, included anthropological and ethnographic documentation, used to reassert the dominance of the rational, educated documenters over their exotic, primitive subjects. Because of the proximity of photography and history – photography as a truthful document of past events – the lens was used as a weapon of colonialism. Now we have *National Geographic.*

Pinar Yolaçan's work disrupts the dialogue between photography and history. To shoot her series of photographs, she travels to remote, often socially isolated, communities, but her images do not pretend to stand for truth or to possess the exotic and unknown. Collaboration with her models is an important element of her lengthy and subversive process. She is looking not for what makes women different but for the things that they share and reciprocate: strength, confidence and power.

Maria (2007), a series of portraits of Afro-Brazilian women, questions the exoticization of non-Western female bodies. The series took three years to complete: the artist spent time in a Candomblé community in Bahia, getting to know each of her models over a period of time. She then constructed costumes by hand, using meat and offal, each outfit designed specifically for each individual woman's body.

The deeply individual approach to her subjects and the personal relationships Yolaçan builds with each of them, combined with their imperious gaze and regal dress, give the portraits a feeling of empowerment and complicity. They possess the image, rather than being objectified by it. They're a vision of matriarchy – past, present, overlooked, forgotten. The costumes they wear are not traditional but are clearly constructions of the artist, while the blank background of the photographs does not fix them to a history, a time or a place.

The meat costumes appear again in Yolaçan's *Perishables* (2001–4), where the artist draws a textural and tonal parallel between female and animal flesh, an allusion to consumer culture's treatment of ageing female bodies. But it is not only that: their fleshiness is of material interest: it changes, transforms and expires. Yolaçan's *Perishables* are visual explorations of flesh as a substance, the way it looks, sits, sags and stretches.

In the series *Mother Goddess* (2009), *Like A Stone* (2011), and the more recent *Corpo Mecânico* and *Nudes* (2012–14), Yolaçan's interest in the physical qualities of a female body, portrayed by the camera, shifts further towards the abstract. In these series, the gaze disappears completely, and a body becomes a malleable, movable form, with bountiful textural and sculptural possibilities. A body that by conventional beauty standards is deemed unattractive becomes a seductive form.

Being a woman from the Middle East, Yolaçan says, gives her a unique access to her models: they react differently to her, and later on, to her camera. The fact she shoots women, though, was not a conscious decision, but a natural interest: 'I'm a woman, my own body happens to be a female body, that's who I am, that's what I am, and I'm interested in the issues that relate to that – it's an ongoing conversation with myself, it's something I think about every day.'

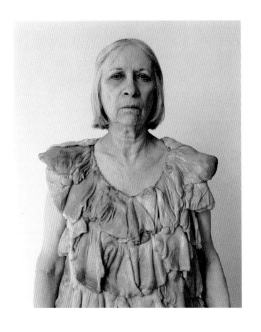

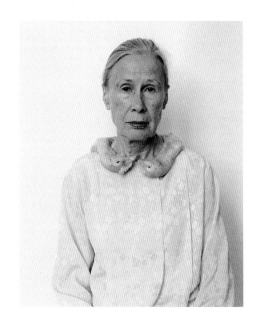

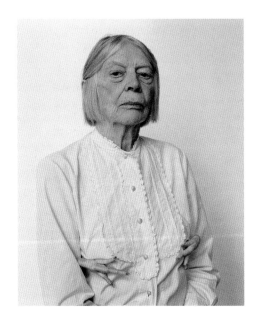

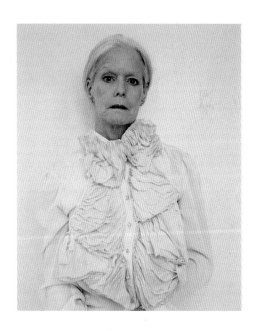

'I'm a woman, my own body happens
to be a female body, that's who I am,
that's what I am ...'

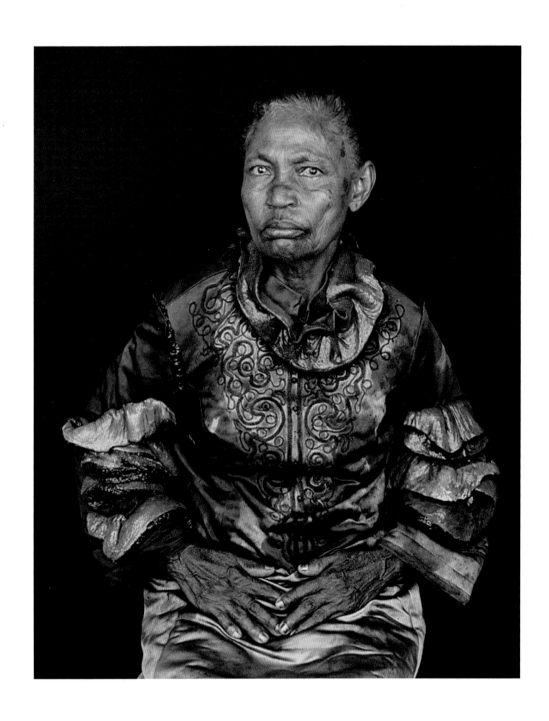

PAGE 78 Untitled (from *Mother Goddess*), 2009
PAGE 79 All untitled (from *Perishables*), 2002–4
ABOVE & OPPOSITE Both untitled (from *Maria*), 2007

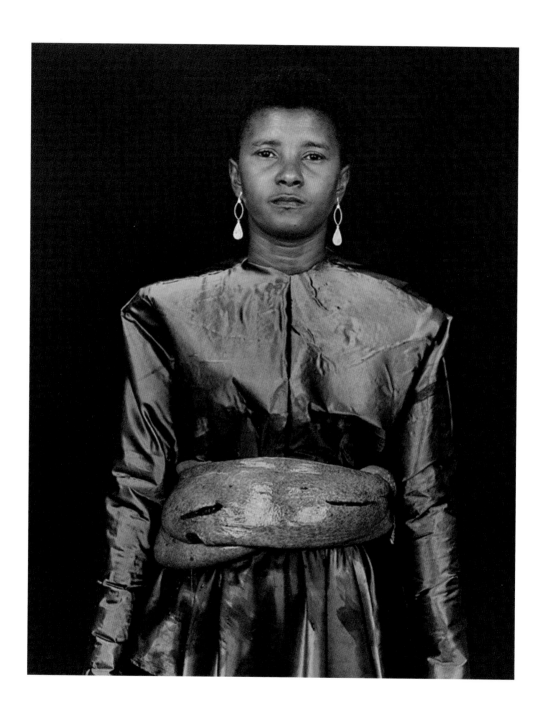

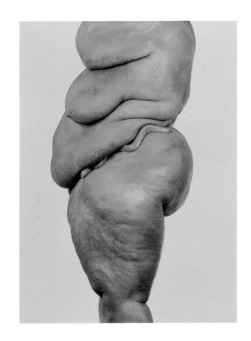

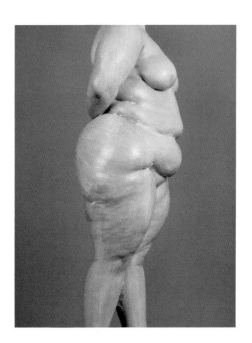

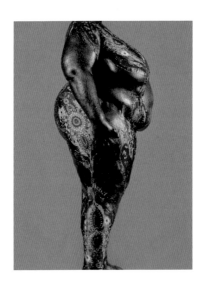

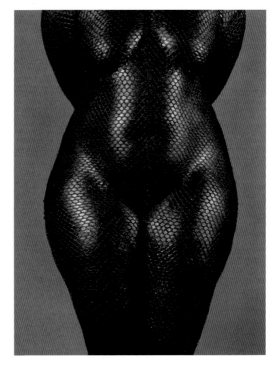

ABOVE All untitled (from *Like a Stone*), 2011
OPPOSITE, TOP Untitled diptych, detail (from *Mother Goddess*), 2009
OPPOSITE, BOTTOM Untitled (from *Mother Goddess*), 2009

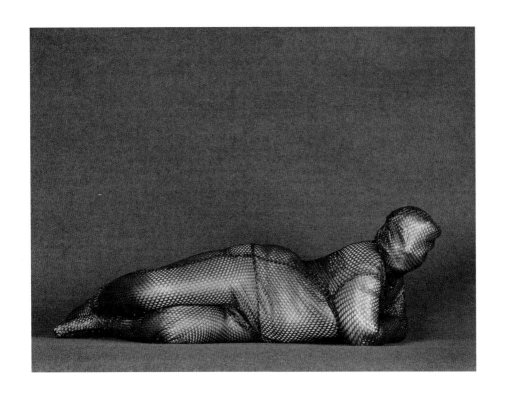

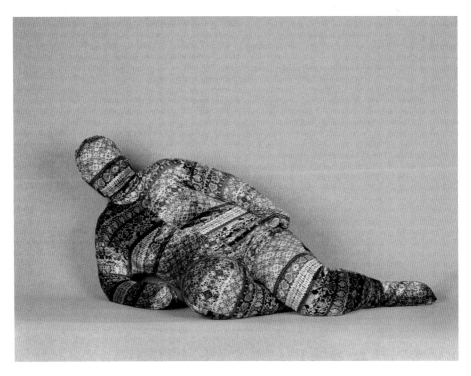

YVONNE TODD

Suburban psychos

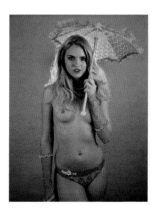

Somewhere deep in the suburbia of New Zealand, Yvonne Todd started out as a commercial photographer, shooting products and weddings. Her early practice has left a trace. Using a fully manual, 'rather cumbersome' 8x10 format camera, Todd's work is couched in the vocabulary of visual storytelling in mainstream culture, though her photographs could never be part of it: 'I'm interested in iterations of awkwardness, of feeling emotionally marginalized. It's how I feel a lot of the time. I'm driven by a vague sense of frustration and rage. But humour is equally important to me. It's the best communicator.'

Todd's female figures have an eerie familiarity. She is inspired by the images of women that are pervasive in the suburban subconscious – soap opera heroines, pop stars, tabloid celebrities, religious women – who are triggers for moments that have marked the artist's psyche. But these are hardly women to aspire to. Todd's persistent palette of greys, browns, creams and beige, coupled with generic studio backdrops, instantly give her portraits the oppressive feeling of a stale, dated idea of bland glamour, flimflam that's reinforced by the shopping-mall sequins, acrylic nails, cheap lace and synthetic satin her characters wear, petrified by their make-up and luxuriantly fake hair.

The familiarity – partly down to Todd's meticulously planned staging and costuming – is quickly compounded by this strangeness that seeps from the photographs: 'My characters are intended to have complex back stories but there's no prescribed narrative. I encourage the viewer to form their own ideas about who the person is and what they're doing. I do feel empathy towards my subjects, but I also like them to have elements of pathos or stoicism,

which I find humorous. A sense of disappointment or deflation – disconcerting aspects that get under the skin. I often think about my relationship with the viewer. I think I can best describe it by saying I want to make people feel uncomfortable but also be my friend.'

It would be too easy – and too safe – to see Todd's characters as a feminist statement. They are open-ended narratives, silent screams. Her characters come off as psychological wrecks, desperate sex freaks, domestic rejects or crazed cashiers. It's not their appearance that's questioned but their whole world, an apathetic world based on seeing and being seen. Todd has been profoundly affected by seeing, having been drawn to disturbing imagery since childhood, when she would leaf through books of disaster, death and carnage in the local library: 'There's an ongoing thread in my photographs of the corporeal and the funereal, ideas that I constantly go back to. There's also a lot of biographical material in my work: fragments of memories, things that stem from real or imagined experiences. I find fetishism interesting, but not the run-of-the-mill stuff; instead, for example, things that are highly specific and to most people deeply unerotic: plain young Christian women wearing spectacles, clad in dowdy dresses.'

Todd's images cut deep into the polished surface endemic in photography of women: 'There's a pervasive sameness to images of women, a digitally sanitized quality.' Young women, Todd says, relate to 'the uncomfortable elements in my portraits and the bluntly defined characters: anorexics, Christians, starlets. There are ideas that don't seem to shift over time. The female experience remains mired in appraisals of beauty and desirability.'

'There are ideas that don't seem
to shift over time. The female
experience remains mired in appraisals
of beauty and desirability.'

PAGE 84 *Did Anybody Tell You That You're Pretty When You're Angry?*, 2010
PAGE 85 *Bo-Drene*, 2004
ABOVE *January*, 2006
OPPOSITE *Female Study (Silver)*, detail, 2007

ABOVE, TOP *Glue Vira*, 2012
ABOVE, BOTTOM From *The Menthol Series*, 1999
OPPOSITE, TOP *Cheer*, 2001
OPPOSITE, RIGHT *Female Study (Gold)*, detail, 2007
OPPOSITE, BOTTOM *Goat Sluice*, 2006

YAELI GABRIELY

The photographic dimension

In Yaeli Gabriely's early works, she saw the photograph as a bi-product of a private performance – a remnant of a ritual – but in recent years her work has become more concerned with the medium of photography itself and the camera has become essential to her practice. Gabriely uses her body in her works because it is what she has available, the last site for experimentation and resistance, over which she has complete sovereignty. So although the first thing we might see is a woman's body in various manipulated and dismantled forms, her work does not speak about her body or female bodies, but rather the experience of disembodiment that photography brings about: 'I was always drawn to digital photography, because it has no matter, no substance, it is only data. Digital photographs are an excellent way to talk about the world because they correspond very well to the way the world is now becoming as we experience it through screens as data.'

Her approach to her body is more like a sculptor modelling clay, to test the limits of perception: 'Since a digital photograph consists only of data, it is like an open file; it begs to be stretched, to be deformed, manipulated, moulded', Gabriely says. She stretches the medium of photography and concepts of truth and reality that are embedded within it by using both physical and digital manipulations that hybridize the 'fake' and the 'real'. Her photographs contain both digital and physical manipulations: on the set, she uses 'real' (whatever that might mean) material props – masking tape, aluminium foil, mirrors, minced meat, feathers, pantyhose, dough – to create 'fake' effects. She takes hundreds of images which she then stitches seamlessly together

in post-production using Photoshop software. In the finished photograph, the digital seams and the live manipulations are indistinguishable from one another. 'When we talk about photography, we often talk about the "decisive moment"', Gabriely continues. 'In my work, there are plenty of decisive moments, but the frame you see never really was.'

With the confusion Gabriely creates, she asks the viewer how, in the age of digital representations, are we ever certain of what is 'authentic'? Why do we prefer the 'real' to the 'fake'? Her work questions the hierarchy of value (fraud, performance, simulation, reality, real) by which we judge what we see. In her work she destabilizes the idea that representation – either in photographs, or in the world – should be deemed either replica or distortion of reality. Instead, she creates a space that belongs exclusively to the medium itself. These are images that never existed as we see them: 'The connection to the world in images is so loose. Photographs are immortal, they are beyond time and space, and they transcend the world and the reality that created them.'

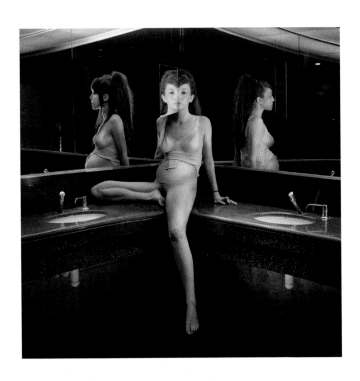

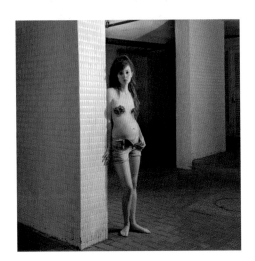

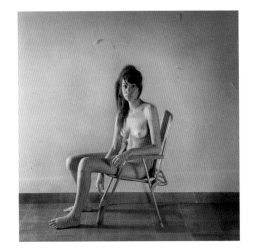

'Photographs are immortal, they are
beyond time and space, and
they transcend the world and the
reality that created them.'

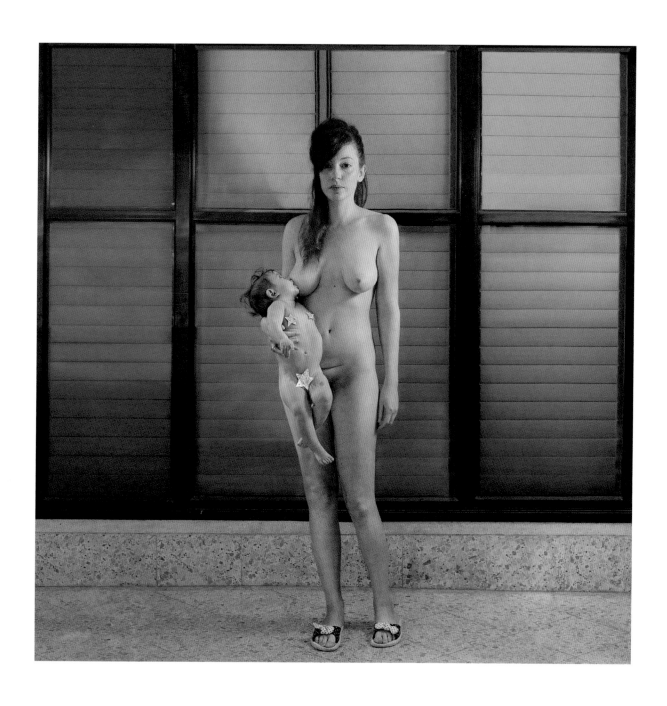

PAGE 90, & PAGE 91, TOP & BOTTOM LEFT All untitled, 2015
PAGE 91, BOTTOM RIGHT Untitled, 2011
ABOVE Untitled, 2014
OPPOSITE *The Tourist/The Monkey*, 2013

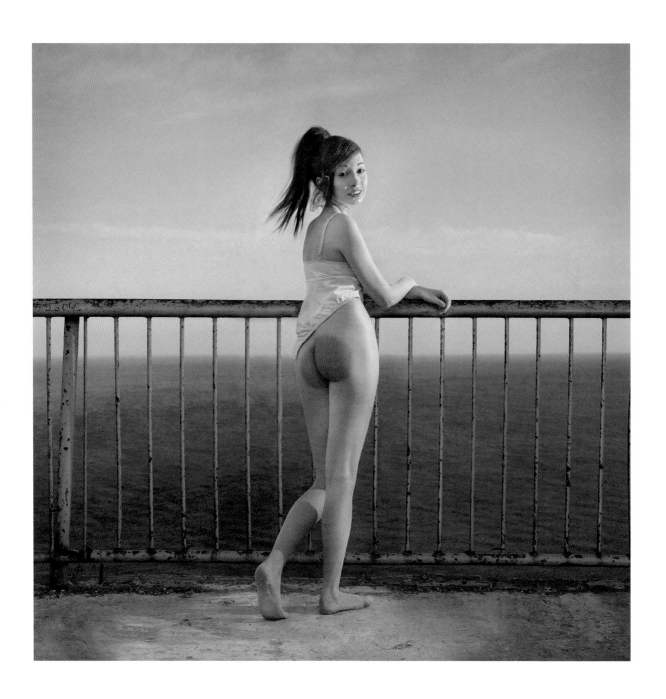

PHEBE SCHMIDT

Photographs for a consumer dystopia

'I think being a woman definitely influences my approach to photographing women', says Phebe Schmidt. Her work challenges the parameters set by images for measuring and marketing female beauty: 'Women are often commodified and objectified in images and I consciously work to create images of women that challenge gender stereotypes of beauty, femininity and sexuality. I think it is important to explore ideas and create narratives that redefine contemporary women as capable and empowered, although at times emotionally vulnerable.'

Conventionally in the past, advertising photography has tried to hide the way it manipulates surfaces such as a woman's skin to make them look normal or achievable to the regular viewer/consumer. Schmidt's ambrosial images give us a flawless ideal that is seductive but blatantly artificial. The everyday and the ordinary become unreal and extraordinary: a doughnut oozing sticky red jam poses provocatively next to a stapler; a block of melting butter is equivalent to a glossy handbag; a woman is packaged in a plastic sheath. What she gives us is impossible or unattainable. Using the familiar language of commercial advertising, Schmidt self-reflexively prods at the plasticity of perfection. When everything is transformed into pristine surface by the camera, the aspirational 'object of desire' is no longer representative of reality. In Schmidt's consumer dystopia, the constructed fiction of the consumer photograph is patent: the camera *can* lie. 'I have always been drawn to the stylistic approach of advertising commercials and the obvious links between objects and aspirational people – the product and person, and how objects can be fetishized and imbued with cultural

capital, particularly in advertisements, and by default the individuals who seek to own these objects. For me, this triggers a desire to create hyperreal narratives that play with the role of objects and their place in our lives, while still creating a desire for the product', Schmidt explains.

This summarizes the position the photographer finds herself facing now: artistic and commercial purposes become blurred. Schmidt works with fashion houses and brands alongside her personal projects, and she is aware that this makes the message of her work and her relation to her subjects more complicated; while the visible artifice Schmidt gives us doesn't try to fool the viewer/consumer, her images are still intended to attract our eye: 'The ambiguity inherent in an image allows the viewer to create their own interpretative narrative of what they see. Conceptually my work is underpinned by constructing worlds – other realities – inhabited by a cast of characters and objects that question what is real and hopefully act as a catalyst for seeing beyond the obvious.'

The paradox of what is real in the world of images is at the core of Schmidt's photography. She stimulates our consumer appetite with images of unnatural beauty to question the way we look at other images of constructed beauty. A handbag can be just as beautiful as a hole-punch, a slab of melting butter or an egg sandwich just as inviting as a designer shoe. Her juxtapositions are incisive and funny but they ultimately encourage us to consume femininity differently: 'I hope to elicit conflicting emotions from the viewer that challenge and question what is beautiful and desirable, and the intention is to move beyond homogenized and generic ideals.'

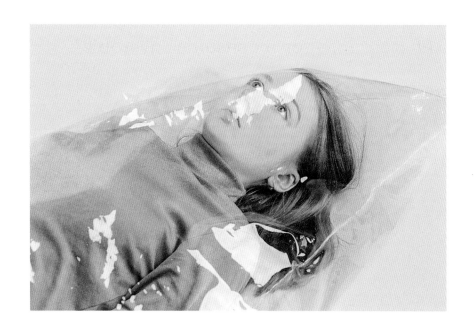

'I have always been drawn to the stylistic approach of advertising commercials and the obvious links between objects and aspirational people.'

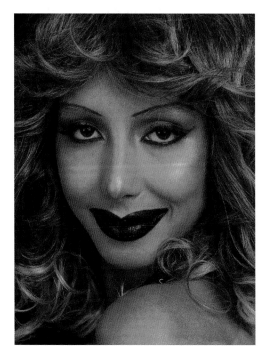

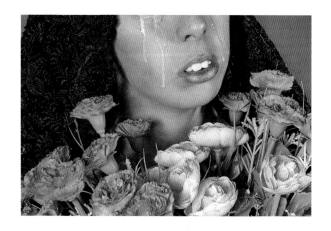

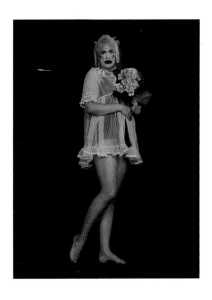

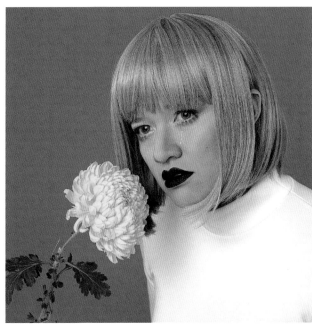

PAGE 94 *Formula 1*, 2014
PAGE 95, TOP *Hermetically Sealed*, 2013
PAGE 95, BOTTOM LEFT, & ABOVE, BOTTOM LEFT *Sweethearts*, 2016
PAGE 95, BOTTOM RIGHT *Martyr's Tears*, 2013
ABOVE, TOP & BOTTOM RIGHT *Secretly Susan*, 2015
OPPOSITE *Chartreuse*, 2015

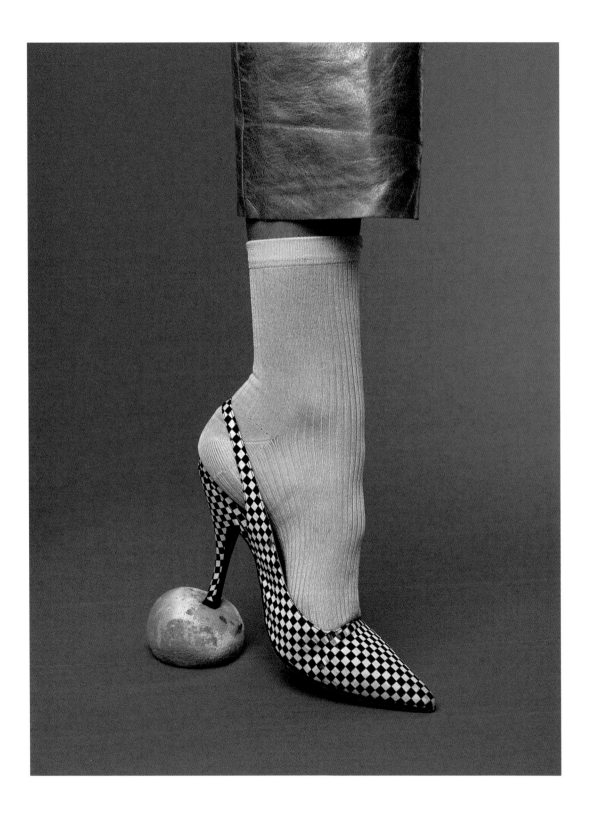

PETRINA HICKS

The female myth

'The more legal and material hindrances women have broken through, the more strictly and heavily and cruelly images of female beauty have come to weigh upon us', wrote Naomi Wolf in *The Beauty Myth: How Images of Beauty Are Used Against Women* (1990). Almost two decades after publication, Wolf's words still feel relevant. The definitions of beauty have diversified in the past 20 years, yet our image-based culture still feeds us with narrow ideas of women – a female myth – that tell us with pictures how women should look, behave and feel.

Until recently, canons of female beauty and femininity have been perpetuated by male artists who depict women as they saw them, for the enjoyment of male viewers. Over time, this male-oriented archetype has shaped how everyone sees women, and it has impacted on our expectations of how women are shown in all art forms. Petrina Hicks traces the myth of women in imagery, from classical art, which posited the idea of beauty as youth and perfection, up to the same ideals in contemporary commercial photography. These limited depictions all have their roots in the male gaze: images of women created by men for men.

Hicks notes that, 'today, image-making is equally in the hands of women, and we are starting to see representations of women through female eyes. However, some female image-makers continue to represent the female through male eyes (perhaps a conscious or unconscious decision). Given that we have an equal amount of female image-makers today, it's interesting that women are still being represented as objects for the male gaze in commercial photography and film. Areas such as science and technology have made radical advancements, yet the representation of women in contemporary image-making hasn't changed much since Renaissance art.'

Hicks is preoccupied with the problematic triangular gaze exchanged between artist, subject and viewer in a photograph: 'I feel a resistance to making images through female eyes at times, because it feels like uncharted territory.' Her work refers to the history of male-made images of women: 'I guess this is a recurring struggle. I'm exploring female identity and representation, and the female figure as seduction tool in commercial photography, yet I'm wanting to create images that are not influenced by the history of male image-making.'

In their composition and form, Hicks's photographs adhere to a purist aesthetic. They are attractive, flawless surfaces, but they are also cold and anesthetic, they deny the viewer. Her female subjects are inaccessible; they float on a blank background like classical marble sculptures – bare of a narrative – idealistic but unreachable, the meaning of the female figure is stripped down to gesture. She shows us that perfection is bland.

In Hicks's photography we cannot penetrate beyond the glossy patina of an image – we cannot possess or 'know' the subject. Contemporary culture tells us we have access to all areas, and that images of women are easy to read, consumable, disposable, but in fact the information we receive from an image is misleading and incomplete: 'How does one challenge or interrogate the exact thing it's posing as? My works look pleasing to the eye, yet within the image there is often something that doesn't deliver, like a rupture in the surface, so it doesn't offer up the pleasure and seduction it's promising.'

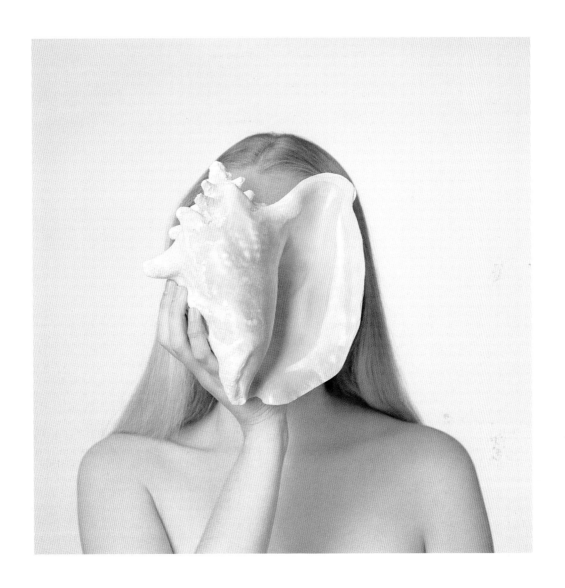

'Given that we have an equal amount
of female image-makers today,
it's interesting that women are
still being represented as objects
for the male gaze in commercial
photography and film.'

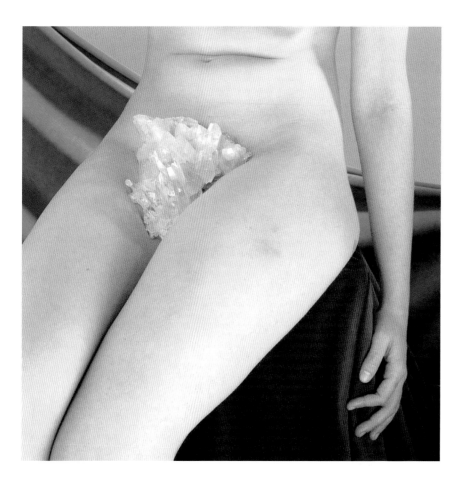

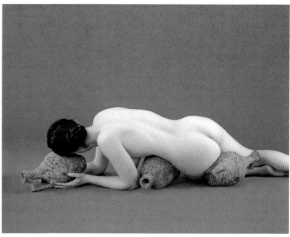

PAGE 98 *The Beauty of History*, 2010
PAGE 99 *Venus*, 2013
ABOVE, TOP *New Age*, 2013
ABOVE, BOTTOM *The Unbearable Lightness of Being*, 2015
OPPOSITE *Lauren with Fruit*, 2011

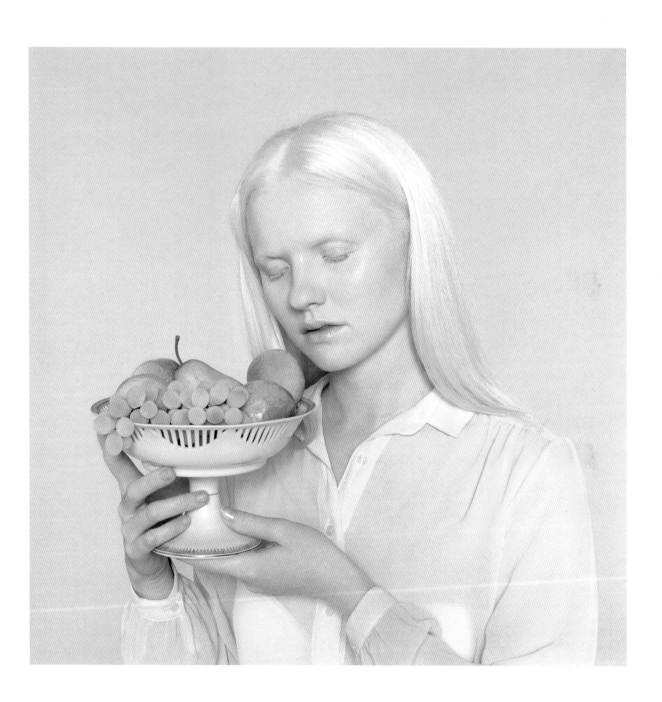

ANJA CARR

Staging the self: sex, Jung and My Little Pony

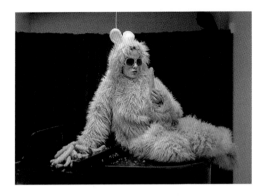

Anja Carr is dressed as an adult version of Pippi Longstocking and is straddling a flat, fluffy horse costume with a determined look on her face. Raw sausages are strewn around the place, soiled with squirts of ketchup. What is happening here?

The viewer who contemplates Carr's photographs – unlike the spectators present at her live performance pieces – enters Carr's fantasy world in the middle of the action. 'I am interested in the transition from performance to photograph – what you miss out and what you gain in this process', she explains. When you see her dressed as Pippi Longstocking, riding her horse costume, you don't see how she lathered the ketchup over the sausages, splashing some on the audience, or how 'the violent whipping of the horse between her legs highlights the sexuality of the character', as Alexander DeBavelaere writes in an essay about the performance, *Horseplay* (2014).

In Carr's ongoing photo series, titled *Moments*, she selects only one photograph to document each of her performance works – conceived of as 'moments' to stimulate the narrative seed of her works for the viewer to cultivate. *Moments* is an experimental exploration of identity construction in the 21st century and the dominant tendency to self-stage in the image-making of internet culture. Carr takes this theatre of the self one step further: her photographs present nightmarish scenarios in a psychedelic kitsch pop aesthetic. Her personae are delusional, a mash-up of characteristics taken from personal, archetypal and collective ideas on sexual behaviour and gender.

Inspired by the Jungian construct of an androgynous psyche – according to which everyone possesses both 'masculine' and 'feminine' traits – Carr plunges into fantasy, perversion and pedagogy. Rather than fix identity in secure terms, Carr uses her theatrical display of costumes and props – made by hand from scratch or reworked ready-mades – to manifest connections between popular figures of childrens' toys, books and TV shows from her childhood (My Little Pony, Ninja Turtles, Miss Piggy, Pippi Longstocking) and polymorphous sexual fetishes and adult dressing-up fantasies like bronies and furries. Carr explains her fascination: 'Both of these contemporary subcultures gather at huge internet forums as well as conventions IRL and have unexpected gender-twists: adult men idolizing "girls' toys" and furry suits hiding original gender.'

Carr plays with the ambivalent and uncomfortable emotions certain visual associations arouse: identity construction in her photographs is lurid and warped. In her live performances, Carr frequently introduces body fluids, body waste, liquids and skin-like materials to her works to provoke strong sensory associations. Yet in her static, two-dimensional works, we don't know if we're looking at a real person or a sculpture. 'I'm interested in Julia Kristeva's idea of the abject, what we find repulsive because it lies between object and subject and thus disturbs social order and conventional identity', she explains. The scene contained in each photograph has the possibility to transform into erotic act or child's play, entertainment or violence, disgust or seduction, dream or nightmare.

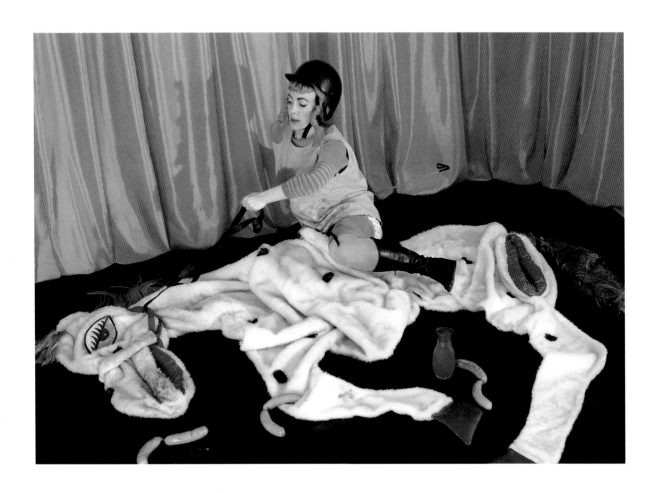

'I'm interested in what we find
repulsive because it lies
between object and subject
and thus disturbs social order
and conventional identity.'

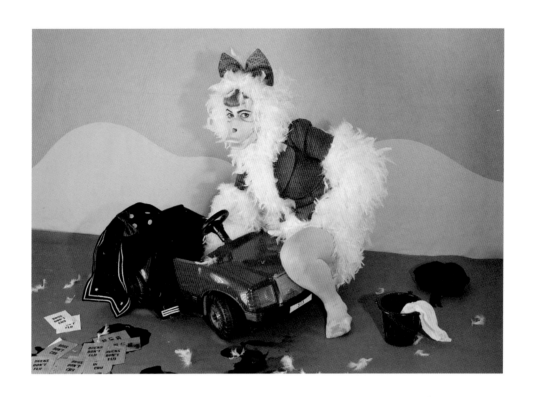

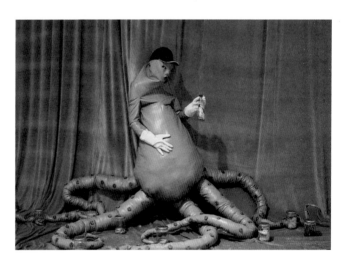

PAGE 102 *Moments (Act 1)*, 2013
PAGE 103 *Moments (Act 8)*, 2014 (from the performance *Horseplay*, 2014)
ABOVE, TOP *Moments (Act 9)*, 2014
ABOVE, BOTTOM *Moments (Act 10)*, 2015
OPPOSITE, TOP *Moments (Act 13)*, 2015
OPPOSITE, BOTTOM *Moments (Act 11)*, 2015

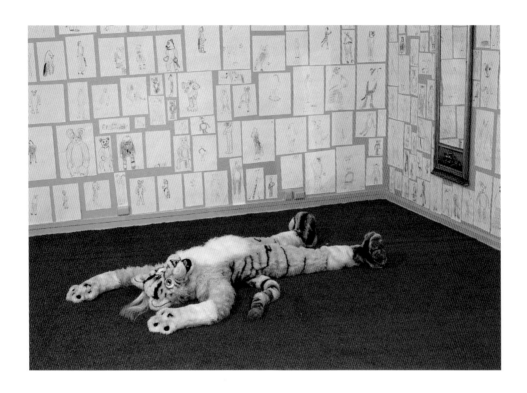

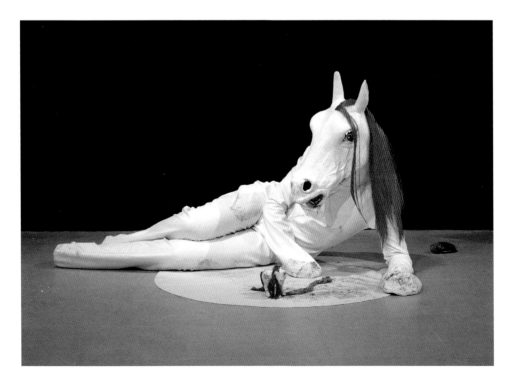

IZUMI MIYAZAKI

Cute and cruel

When Izumi Miyazaki was studying photography she asked to create portraits, but no one wanted to pose for her. So she took pictures of herself, though she sees the roles of photographer and model as distinctly separate: 'Even though I am making self-portraits, I do not feel that it is the same person in front of and behind the camera.' Her photography has received wide exposure both in Europe and the USA, but in her native Japan the reaction has been 'much less enthusiastic', she says. 'I believe that it is expected of a young Japanese female photographer to create images that are a little more "kawaii" [cute] or a little less "kowai" [scary]!'

In spite of this, Miyazaki does not believe that Japan 'is as sexist as we could believe from the outside. Indeed, I believe that the position of women in Japanese society could be envied by many other cultures.' I wonder if she thinks there are inequalities in the working world, given her own observations of the way her work has been appraised? 'It is true that there are undoubtedly still efforts to be made concerning, for example, career opportunities for women', she concedes.

Of her own working method, Miyazaki says, 'when I compose my pictures, I sometimes have a very clear idea of what I want to do, but during the creation process, chance makes me take a completely different direction. My pictures come from my present mood and my surroundings.' Miyazaki's use of humour in her self-portraits also has a cathartic effect for the young photographer: 'The grotesque side of some of my photos comes maybe as a way to exorcise those memories and the fear of death.' She also notes the influence on her work of 'dorama' (Japanese television dramas), which often feature rather shocking or violent images.

Miyazaki's artistic process is surprising and unusual. 'First, an idea comes to mind, like something I want to eat (I love eating!). So I imagine a scene with soup, onigiri (rice balls) or tomatoes', she says. This could offer one reading of the recurrent motif of Japanese culinary culture in her work as a visual diary of the artist's appetite, but there is something more to it – a sense of the morbidity that comes from relentness consumption. She turns herself into sashimi or a sandwich, a consumer and a product, who appears to be measured up on the production line to be chopped up, processed and digested. Her fascination with food thus becomes intertwined with her concerns about dying, the photograph a way to interrupt the inevitable with the unexpected.

Miyazaki's flat-pop aesthetic, by turns surreal, comic and gory, might not be considered conventionally feminine in Japan, but outside her native country it appeals to a desire for fantasy in photography, where the camera is used to examine the interior world of the photographer rather than to record reality. Miyazaki introduces aspects of Japanese culture that are recognizable to an outsider as much as to a local, but she does not comment on the fetishistic view typically found in photographs of Japanese women. Her images do not depend on the construction of gender or sex: 'Apart from the fact that I am a Japanese woman photographing a Japanese woman, I have no particular message to transmit to the society around me. Unless I am unconsciously the reflection of it.'

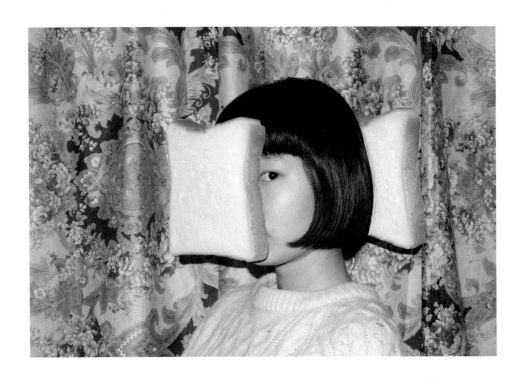

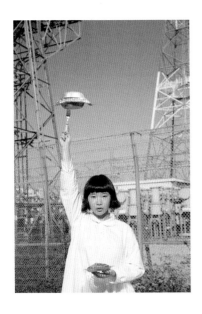

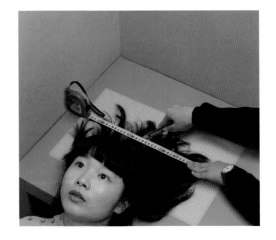

'Even though I am making
self-portraits, I do not feel that
it is the same person in front
of and behind the camera.'

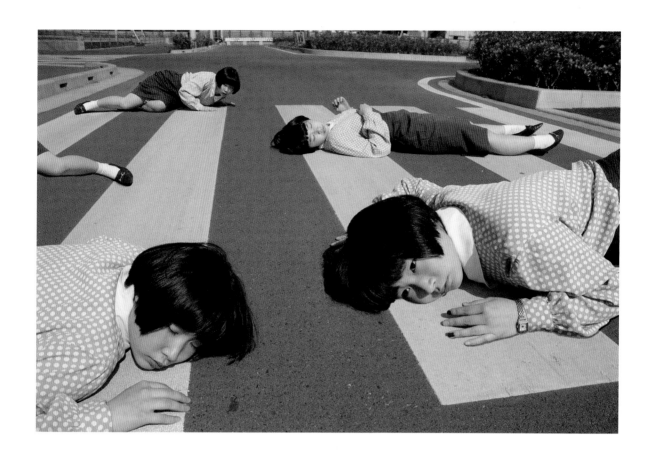

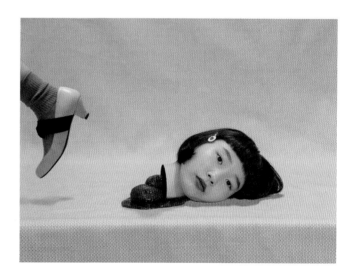

PAGE 106 *In My Eye*, 2013
PAGE 107, TOP *Sandwich*, 2013
PAGE 107, BOTTOM LEFT *UFO*, 2014
PAGE 107, BOTTOM RIGHT *Hair Cut*, 2016
ABOVE, TOP *Consciousness*, 2015
ABOVE, BOTTOM *Tomato*, 2015
OPPOSITE *The moment I become an object*, 2015

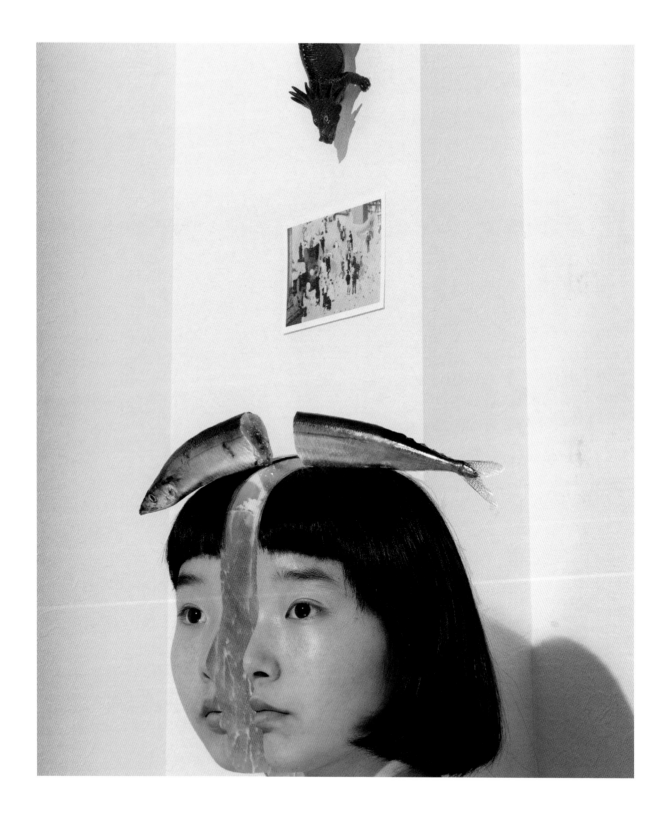

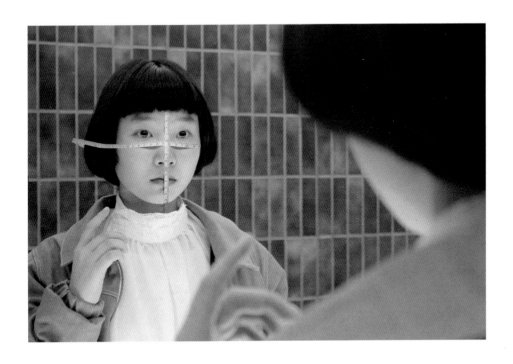

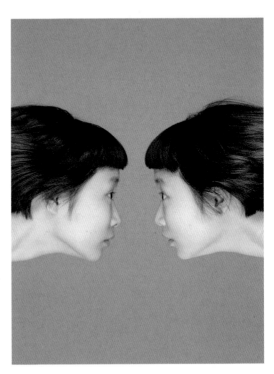

ABOVE, TOP *Measure*, 2014
ABOVE, BOTTOM *Face to Face*, 2015
OPPOSITE *Cloud 1*, 2014

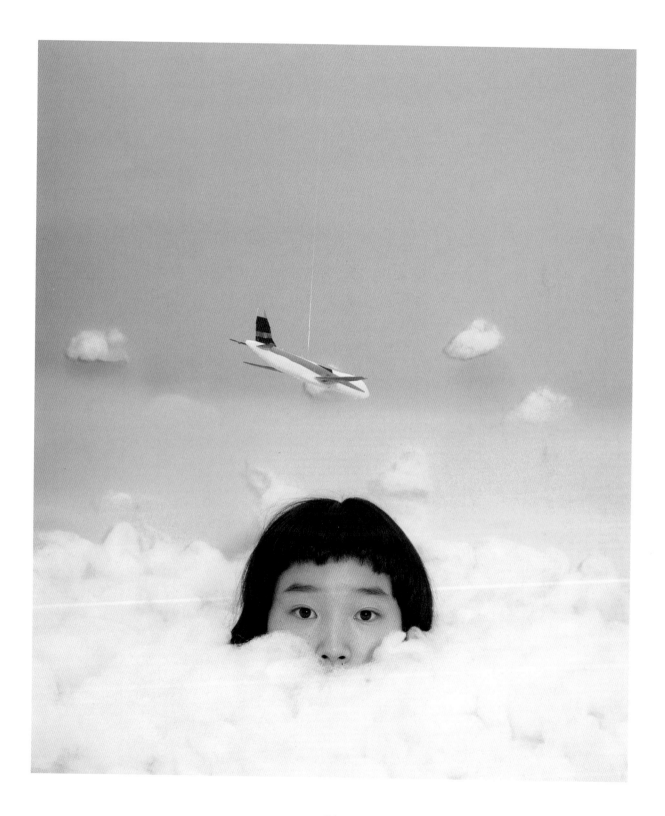

JUNO CALYPSO

Performing solo romance

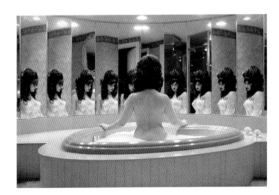

All lens-based practice borrows from elsewhere, but in the discussion of female photography today, comparisons with the artist Cindy Sherman are constant. In the case of Juno Calypso this is perhaps unavoidable but, as she notes, 'women dressing up and taking pictures of themselves is a historical, global practice. Yes, Cindy Sherman is a major example of this genre, and so far as that goes, my work could be described as reminiscent of Sherman's. But I would never describe it as pastiche. Pastiche suggests irony and I don't think my work is ironic. It also suggests an avoidance of serious intention – while some of my images might make a viewer laugh, there is an underlying sense of sadness and seriousness about it.'

The narrow scope for contextualizing female photography and the dissonance of the female archive in cultural history means that the nuances in new work are often overlooked. 'Why is there only room for one female artist to be doing this?', asks Calypso. 'Growing up in the digital age, I've been taking photographs of myself since primary school. When I was a teenager I'd dress up in my bedroom and take coquettish pictures of myself on a camera phone. Now, working as an artist, it is interesting to interpret my work in relation to that of other artists, but there is no direct parody or pastiche for me because this is a deep-rooted urge, not just a style of art I fancied having a go at.'

In her earliest works, Calypso performed her alter ego as oppressed – her face literally smothered by a beauty product, a wig, a floor, or a pillow – by the efforts of constructing clichéd feminine identity. But in her later works – particularly *A Dream in Green* and *The Honeymoon Suite* – Calypso shrugs off the constraints of those earlier references. Her laboriously constructed femininity shifts from being comically oppressive to powerfully expressive. Juno went to great personal lengths to fund her solo trip to a love hotel in Pennsylvania in 2015, where she spent a solid week shooting round-the-clock, alone. She explains: 'I packed a suitcase of wigs and wedding lingerie and told them I was a travel writer. Eager for a good review, they handed me keys to every room in the resort. I exploited them all as stages for new work, and so we find this character, or maybe an array of imaginary women, in these solitary moments of preparation and anticipation.' Her efforts have paid off. Since 2015 she has received several awards for the work and has shown at exhibitions in London and New York.

From the stifled figure she performed previously, these portraits celebrate the decadence of private fantasy, the same satisfaction the artist professes she finds in putting on her personal performance, devising a costume and acting out a role. The solitary enjoyment in photographing herself – performing for her own camera, for her own gaze – is coupled with the ambiguity of the performed character reflected in the mirror. The honeymoon suite as the set for the performance is both a triumphant expression of self-realization and advocate of self-exploration that rejects the conventional idea of romance, but it has also been read as a testimony of loneliness.

While taking her time, as she does with everything she puts out, to figure out her own views on feminism (a term Juno has never attributed herself to her work), the twenty-six-year-old artist is enriching her practice with careful and expansive questioning that goes far beyond the image.

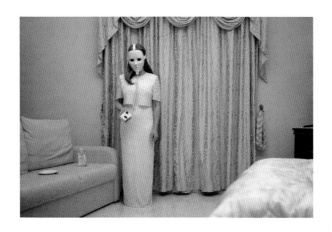

'... we find this character, or maybe
an array of imaginary women,
in these solitary moments
of preparation and anticipation.'

PAGE 112 *The Honeymoon Suite*, 2015
PAGE 113, TOP *12 Reasons You're Tired All The Time*, 2013
PAGE 113, LEFT *Slendertone I*, 2015
PAGE 113, RIGHT *Reconstituted Meat Slices*, 2013
ABOVE *A Dream in Green*, 2015
OPPOSITE, TOP *The Champagne Suite*, 2015
OPPOSITE, BOTTOM *Massage Mask*, 2015

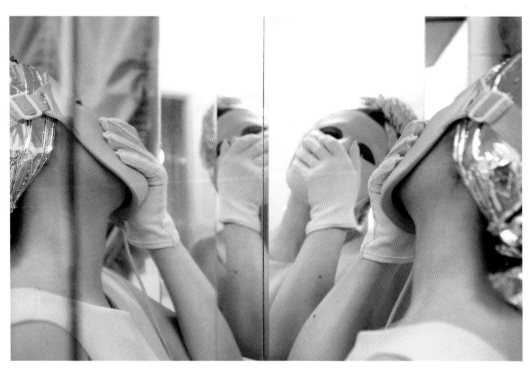

NAKEYA BROWN

On hair

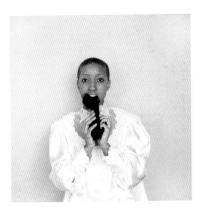

Photography is an effective platform for women to share their own experiences and a democratic tool for responding to expectations and common beliefs about femininity. The struggle with our hair as women is often symbolic of our struggle to conform. Nakeya Brown's photography contextualizes this experience from her standpoint as a young black woman in the USA: her images read as a celebration of the agency of black women and black beauty culture as much as they provide a space to redress the dominance of the white female perspective in our image culture.

Hair isn't just hair. In Brown's work, hair intersects with conversations on identity, body image, self-care, popular culture, feminism and the contemporary black psyche: 'So much is packed into hair, which makes it a viable site for resistance. It's regulated along so many gazes. Whether a woman is choosing to grow hair on her underarms and legs to reject patriarchal standards or she is dreadlocking her hair to reject Eurocentric standards, there's agency in connecting our own body to our protest.'

As Brown suggests, although that protest manifests itself through her subjective experience, her aim is to connect with other women: 'Women's bodies are experienced in shared ways and women's bodies are scrutinized in shared ways. I was really interested in exploring this sharing of social experiences, both positive and negative.' In her work, Brown contemplates how the identities of black women in mainstream America in the past (*If Nostalgia Were Colored Brown*), her own family's rituals (*Hair Stories Untold*) and current discourse on beauty

(*The Refutation of "Good" Hair*) can create a more meaningful and inclusive space for the black feminine experience.

The shared experience of black women begins in her work in the realm of the personal: self-care rituals passed down through female generations. In *Hair Stories Untold*, Brown selects everyday beauty tools from the past (hot combs, hair pomade), items that are common to many African American households. As a child, Brown would watch her grandmother 'part, grease and roller-set her hair', learning how to do her own hair. Now a mother herself, Brown evaluates the way self-image and self-worth are constructed through these specific rituals that are passed down, as well as how that didactic process creates ideas of the self in relation to the perception of others: 'Through the grooming of hair we learn codes of conduct, we learn obedience. That liminality brings someone, somewhere, great comfort.'

In her photographs, Brown introduces braids, weaves, straightened, natural and Kanekalon hair. Although her images have a specific resonance for black women, her images speak of the way we see all women. In *The Refutation of "Good" Hair*, Brown directly addresses the term 'good hair' and the ideology that goes with it, subverting the dichotomy by which women are measured and deemed attractive. Rather than juxtaposing good hair/bad hair, attractive/not attractive, natural/unnatural, Brown juxtaposes hair with food in the series – it's curled around a fork, or being eaten by her subjects – as a metaphor for the way we all consume racialized ideas about beauty.

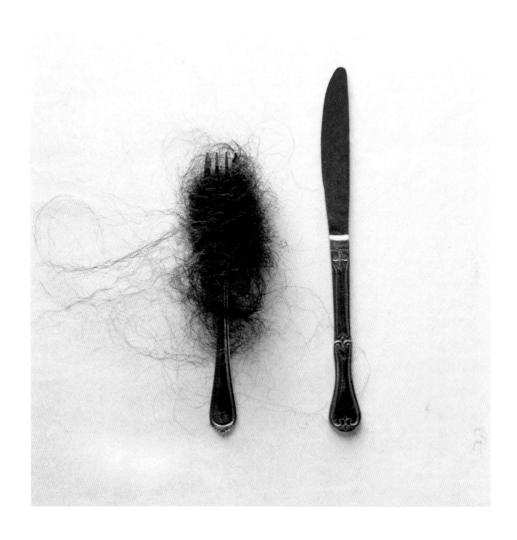

'Through the grooming of hair
we learn codes of conduct,
we learn obedience.'

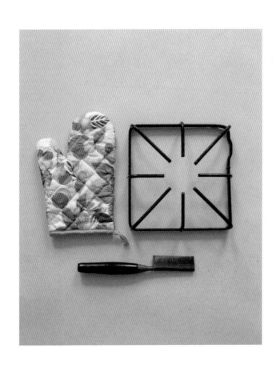

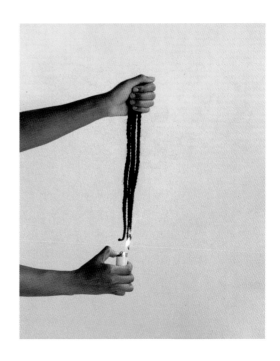

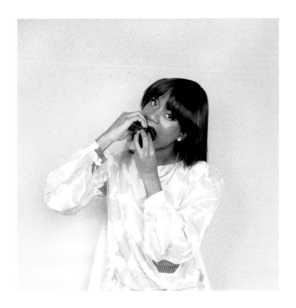

PAGES 116 & 117, & ABOVE, BOTTOM LEFT From *The Refutation of "Good" Hair*, 2012
ABOVE, TOP LEFT & RIGHT, & OPPOSITE From *Hair Stories Untold*, 2014

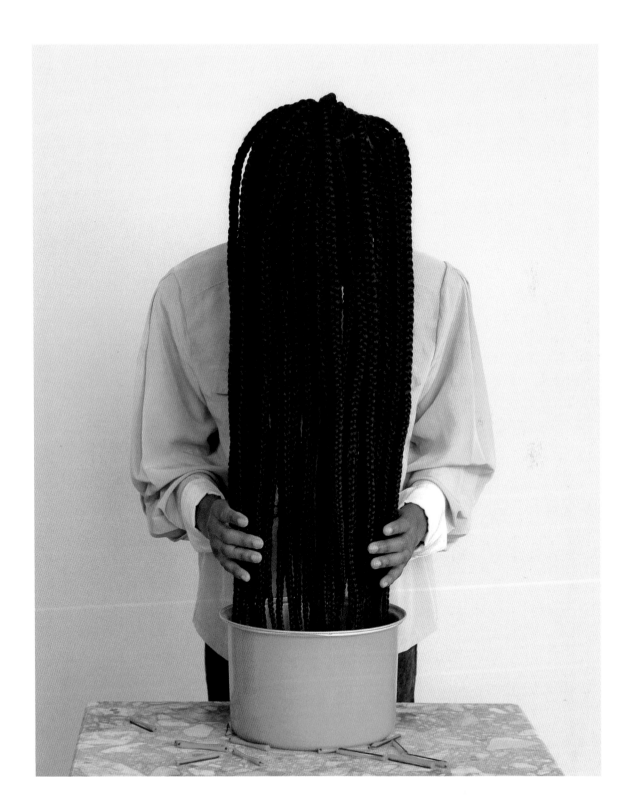

PIXY LIAO

'How could you treat your boyfriend like that?'

Pixy Liao's earliest works featured her boyfriend: 'I kind of used him as a prop in my photos. Sometimes I would ask him to play a dead body, or to be naked and fit inside a suitcase. When my class saw my photos, the first thing they would say was not about my work but, "How could you treat your boyfriend like that?" I was surprised by their reactions.' The reactions pushed Liao to probe ideas about women in relationships with men even further in her work, by portraying herself in a dominant role, in an ongoing series titled *Experimental Relationship*, started in 2007.

In Annie Leibovitz's iconic 1980 photograph of John Lennon and Yoko Ono, Ono is fully clothed while Lennon is fully naked. It was an accidental moment (Leibovitz had planned to photograph both of her subjects nude but Ono was reluctant to undress for the camera) that ruptured conventional depictions of heterosexual couples in contemporary photography, and yet in the almost four decades since, we're still not used to seeing women portrayed in positions of power in mainstream visual culture. In Liao's work, the artist often remains clothed, like Ono, and assumes a physically dominant position in the poses she performs with her boyfriend. 'I do think my partner's naked body reveals his vulnerability. I like seeing the naked male body more than the female body. People are so used to seeing naked women in art. As a woman, I'm not so interested in the female body. I find the naked female body too sexual, which could lead to unnecessary assumptions about my work.'

Liao prefers to see her work as pro-female, rather than belonging to a feminist canon: 'I never thought myself as a feminist. After my work was circulated online, my attention was drawn to its relation to feminism. I did follow up on some discussions and read a little bit about feminism. There are indeed many similar ideas in my work, but the main reason I don't consider my work to be feminist is that I don't advocate for female equality. I believe not everyone deserves the same power nor do they share the same responsibility. People are born differently, men and women.'

Liao's thinking is intersectional nonetheless: culture dictates interactions, desires, needs and expectations as much as our bodies: 'My boyfriend is Japanese and I am Chinese. Our cultural backgrounds are similar, but also vastly different on certain issues. Our relationship now is still affected by the relationships between our two countries. In my photos, sometimes it's about support, sometimes it's about control; sometimes it's about distance – very much like the relationship between the two countries. I also draw inspiration from both cultures. The ideas can come from a Chinese proverb or a Japanese cultural practice, for example.'

Moving from her native Shanghai to New York gave Liao the opportunity to make this kind of work at all. In China, censorship prevents her from presenting her photography freely: 'I found people of different cultures have different reactions to my work. In general, I find the US and Western audiences like to see different ideas with regard to gender identities. But my work resonates more with an Asian audience, because we come from a similar cultural background. Particularly young women in China – they know exactly the kind of expectation of relationships I experienced growing up. But I think the general public in China is still not ready to see work like this.'

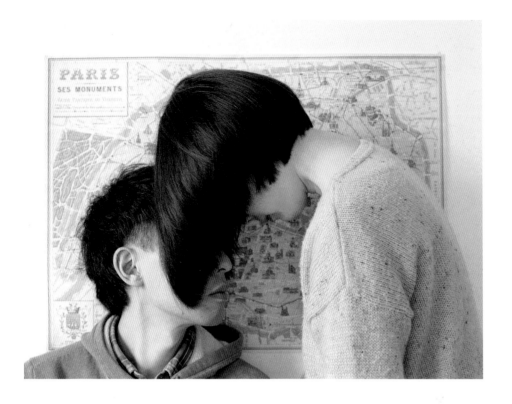

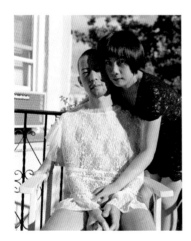

'People are so used to seeing naked women in art. As a woman, I'm not so interested in the female body.'

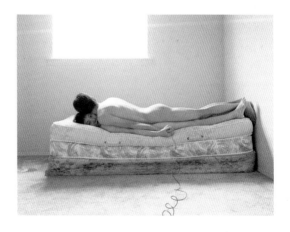

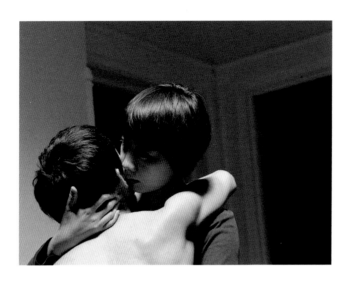

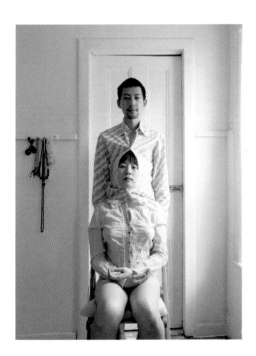

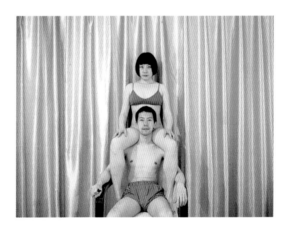

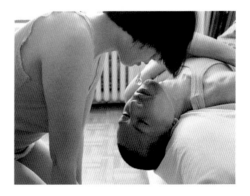

PAGES 120–123 All from *Experimental Relationship*, 2007–16

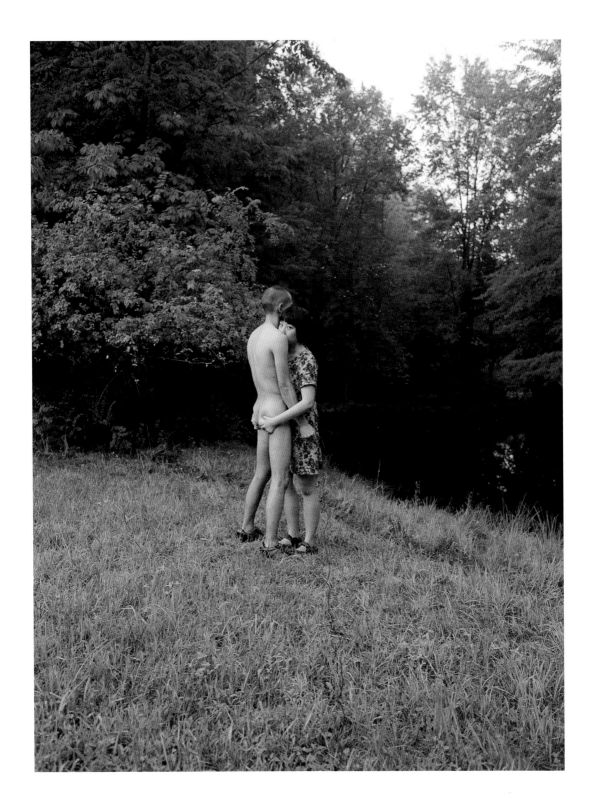

ANETA BARTOS

The erotic and the female gaze

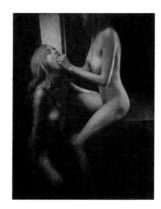

In the discussion of the sexualized female body, the male gaze often concerns us. But what about what women see?

In early examples of erotic photography, such as the works of Bruno Braquehais, Louis-Camille d'Olivier and Auguste Belloc, a man depicts a woman's sexuality for a male viewer, and the female subject often looks back at the viewer, in tacit complicity. The aim is to seduce the heterosexual viewer. 'I am a female gazer and I am looking through my own female perspective both at men and women', Aneta Bartos says of her work with the erotic body, both male and female (in her series *Boys* and *4 Sale*, respectively). 'Male gaze suggests that women can be made to view the world and themselves through the eyes of a male, and the woman is expected to be the gazed-upon, not the gazer. This has been a very well-established male-power phenomenon that some women, including myself, have begun to face and challenge.'

Bartos's female subjects do not return the viewer's gaze: 'I wanted to keep my subjects hauntingly intimate and anonymous. My aim was to generate a self-sufficient, sexually and dangerously charged world of females, completely independent of men and their gaze.'

For many women, arousal is ambivalent. Bartos gives us this sensation in the murky, phantasmagical atmosphere of her photographs with their open-ended narratives. She alludes to the aesthetics of early erotic photography in her settings and in her preference for shadowy, sepia colours and soft focus, while the gestures of her models are informed by the myths of ancient polymorphous sexuality and ritualistic practices. This is evident in her *Spider Monkeys* series (taking its name

from Mayan society), which imagines a dualistic sexual being where the spiritual self and the physical body are reconciled as one.

Given the social implications bound to the act of photography today, is using the female body an effective model for subverting patriarchal paradigms in art? 'It's an excellent method to establish the authority of a female gaze, achieve freedom and equality by means of exposed reflection of insight, and finally stopping sexual oppression of women', Bartos asserts. In her work of Sapphic erotica, *4 Sale*, the photographer is also photographed with her models.

Men and women have worked prolifically with the female body in photography but disproportionately few work with the male body. This only exacerbates the chasm in perception between men and women and how they should look and behave in front of the camera. In her images of men masturbating, *Boys*, however, Bartos's position as a female gazer somehow becomes more problematic: 'It seems that artwork with sexual representation, especially of male nudity, is often assumed to be made by a male. We have only seen a few female artists who have managed to have a successful career working with male nudity, and even fewer who make them with an objectifying gaze. This probably has something to do with the awkward reactions from the art world and society as a whole.'

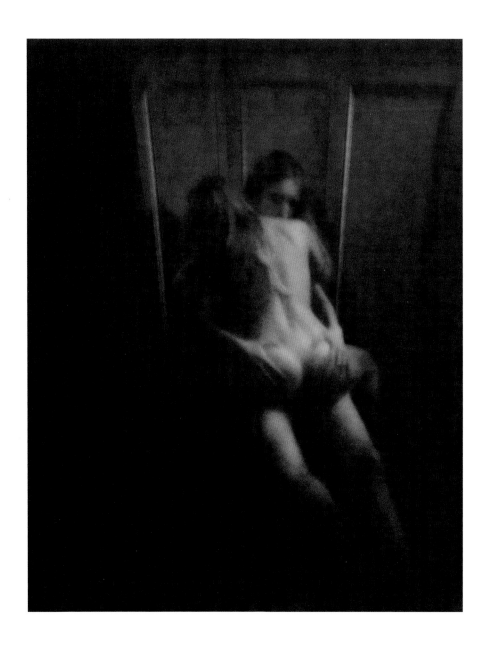

'My aim was to generate a self-sufficient,
sexually and dangerously charged
world of females, completely independent
of men and their gaze.'

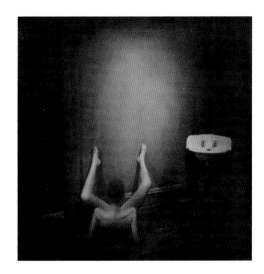

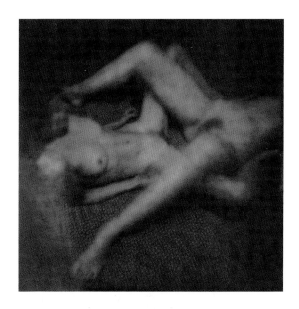

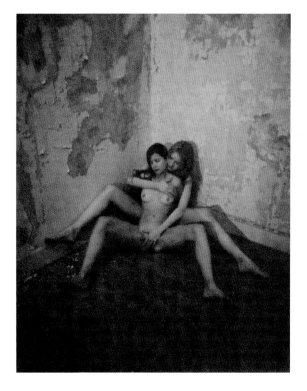

PAGE 124 *Feed* (from *4 Sale*), 2010
PAGE 125 *Embrace* (from *4 Sale*), 2010
ABOVE, TOP LEFT *Argiope* (from *Spider Monkeys*), 2013
ABOVE, TOP RIGHT *Spread* (from *4 Sale*), 2011
ABOVE, BOTTOM *Widows* (from *Spider Monkeys*), 2010
OPPOSITE *Cetos* (from *Spider Monkeys*), 2015

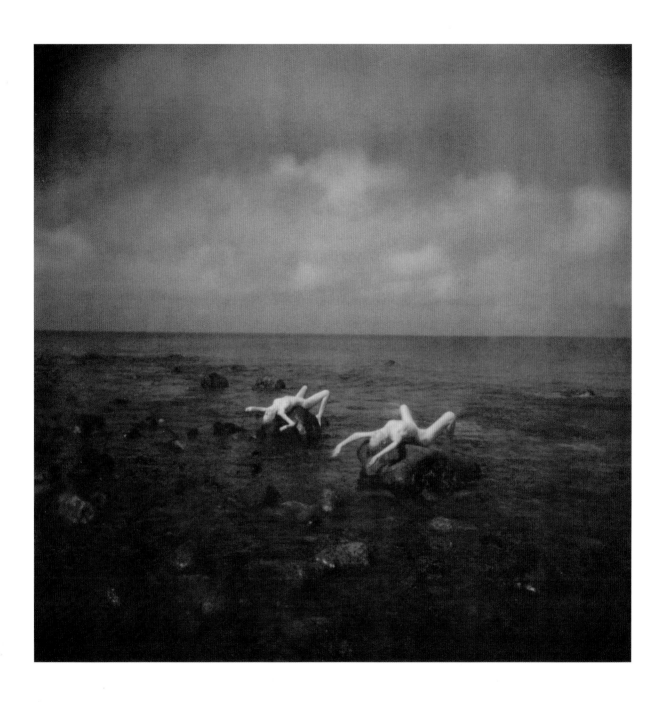

NATHALIE DAOUST

A hotel room of one's own

There are not many things, in the second decade of the 21st century, that have not been photographed. Not only are we saturated with images, but the limits of these photographs in understanding reality are widely accepted, though since its inception, photography has contributed to the destigmatization and demystification of the unfamiliar, the unknown and the unappreciated. Taboos might not have been entirely dismantled by photography, but portraits of lives in peripheral communities have contributed to a more nuanced worldview. This process, as Diane Arbus wrote, makes photography a perverse act.

Nathalie Daoust's images are not intended to shock – and they probably do not shock the average viewer today. Her strategy is not to show the sex workers she photographs as either victims, or as empowered or glorified, but she does believe in photography as a tool to reevaluate our relationship to the unknown. Her lens has allowed her to explore her own curiosity in women who work in environments very different to her own and to challenge her own preconceived notions of their hidden worlds.

From an early project in the late 1990s in New York, documenting the inhabitants of the historic Carlton Arms Hotel, Daoust travelled to Tokyo, where she spent years photographing portraits of women who perform striptease (*Tokyo Girls*), and later, of 39 workers at the Alpha-In, one of Tokyo's largest S&M love hotels (*Tokyo Hotel Story*). For another project – *Street Kiss* – she visited the Nicacio brothel in Davida, Rio de Janeiro, to photograph prostitutes working there who have established their own fashion line, Daspu, making the clothes in their spare time: 'I don't see what they do as shameful – neither do they.'

What emerges through Daoust's depiction of these women is the connection between the erotic and escape – whether from a stifling culture or oppressive economy: 'I have spent much of my career exploring the chimerical world of fantasy: the hidden desires and urges that compel people to dream, to dress up, to move beyond the bounds of convention and to escape from their everyday life.' Her imagery is sensual and seductive, but it is also clear that each woman is performing her own role, and escaping her own reality. This is Daoust's challenge to the fixed frameworks we have for viewing and dealing with women and sexuality in photography. What you get is not what you see.

A photograph is always limited in its ability to convey experience. Daoust admits, 'you can't tell the whole story with a photograph' – it is too narrow to explain the working and private lives of the women she met, many of whom she got to know intimately. We, like Daoust, are outsiders, who look on like a voyeur, passive and detached. When the images travel in their new life as printed and exhibited photographs, we do not see everything that Daoust saw when she took the photograph, and we cannot understand each woman. Yet precisely because photographs are reductive – they are only glimpses of a distant world that remains unknown and inaccessible to the viewer – they evoke fantasy. Everything in the image alludes to the creation of an alternative world, removed from time and place: their dress, the props, the lighting, and the setting of their hotel rooms, a constructed set or stage for their private performance exhibited for Daoust's lens.

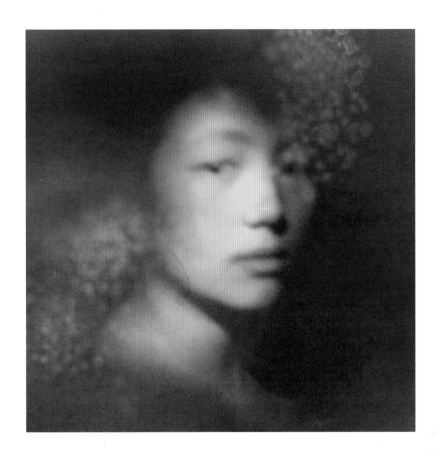

'I don't see what they do as shameful – neither do they.'

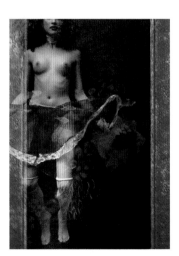

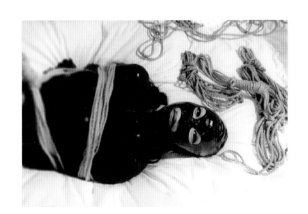

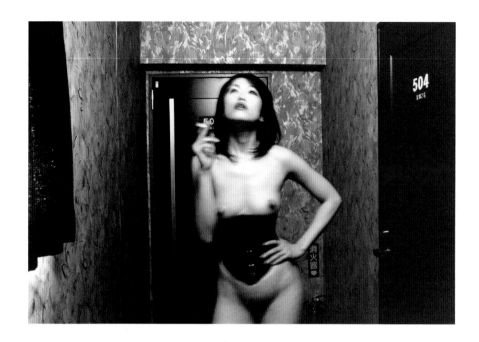

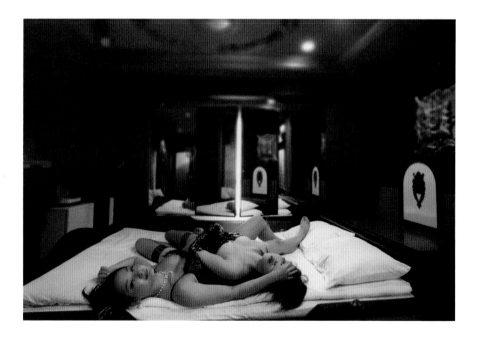

PAGE 128 From *Tokyo Girls,* 2001
PAGE 129, TOP From *China Dolls,* 2009
PAGE 129, BOTTOM RIGHT From *New York Hotel Story,* 1999
PAGE 129, BOTTOM LEFT; ABOVE & OPPOSITE All from *Tokyo Hotel Story,* 2008

ABOVE Both from *Tokyo Hotel Story*, 2008
OPPOSITE From *New York Hotel Story*, 1999

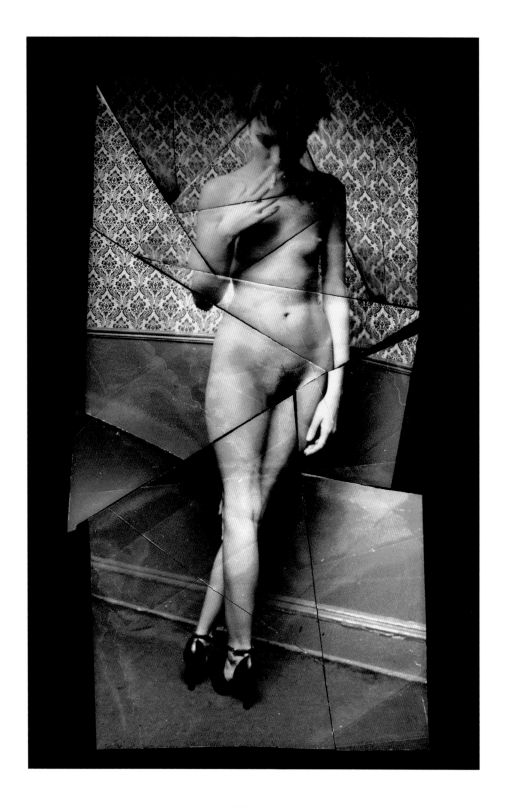

MARIANNA ROTHEN

A sublime breach

When social media activists Lily Bolourian and @Cheuya launched their 2015 #FeministsAreUgly campaign, their motivation was to take down the 'cisgender white woman supremacy' in representations of beauty. 'There is no universal experience of being a woman', they declared.

The online platforms at our disposition now have helped to disseminate genuinely diverse ideas on what is beautiful – and to rebut mass-media definitions – but female beauty will always be a contentious issue: no matter how broad our definitions are, as long as beauty is encouraged as a social tool, a hierarchy will persist. In our current culture – where editing and sharing photos of ourselves is the norm – we've created a new phenomenon, where we present images of ourselves as we'd like others to see us. It's a common habit to compare ourselves not to images of other women but to ourselves: internal standards are as much of an issue as those dictated by the outside.

Marianna Rothen's consciously beautiful images of women might feel as though they contribute to our beauty mania. Her dreamy female muses seem to have stepped straight out of a '60s silver screen, frolicking with confidence in bucolic places, picnicking or playing the piano. They are sumptuous testaments to the power of beauty and they are gorgeous to look at.

The beauty in Rothen's works is unapologetic. Beauty, they suggest, has to have a place. For Rothen, the truth of beauty escapes reality, rather than represents it: 'My work is about creating a mood that is not from this time and I am happy if my images can transport the viewer elsewhere. There are so many interesting criticisms and topics within the scope of the feminine ideal. It's different for everyone.

I like my women to be more iconic than realistic. Showing something bluntly to me doesn't have the same potential for narrative. It becomes documentation with a very specific date attached. To me creating truthfulness doesn't require truthful representation.'

Through the female lens, we are able to see the many ways in which women respond to female beauty. At first look, Rothen's images appear to view women aesthetically and idealistically, as a heterosexual man might. Yet this is the female artist's prerogative, since men have been permitted to freely create this vision of women since the beginning of art without being held accountable. But Rothen's images on closer inspection offer more than the mythology of beauty. Her female figures are not passive muses but each enacts their own silent, mysterious story: 'I'm trying to develop a narrative together with the women I photograph. They have feelings and are very much alive within their characters. They exist further than the bounds of the photograph. Objectification is a matter of perspective; I'm looking for emotions that I identify within these images. Even though I depict beauty there is an inner life and an innocence to the women that is crucial to me. Beauty then becomes a vehicle, something more interesting.'

The philosopher Giorgio Agamben once described the photograph as 'more than an image, it is the site of a gap, a sublime breach between the sensible and the intelligible, between copy and reality, between a memory and hope'. If Rothen's mystifying women are unrelatable or distant from us, then they have performed their proper function.

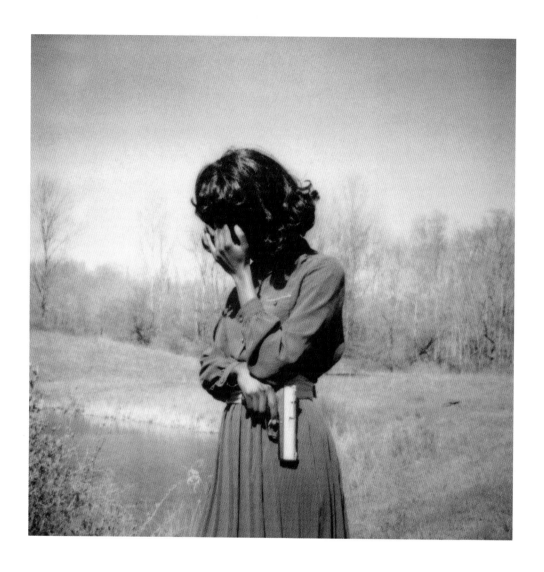

'I like my women to be more iconic
than realistic. Showing something
bluntly to me doesn't have the same
potential for narrative.'

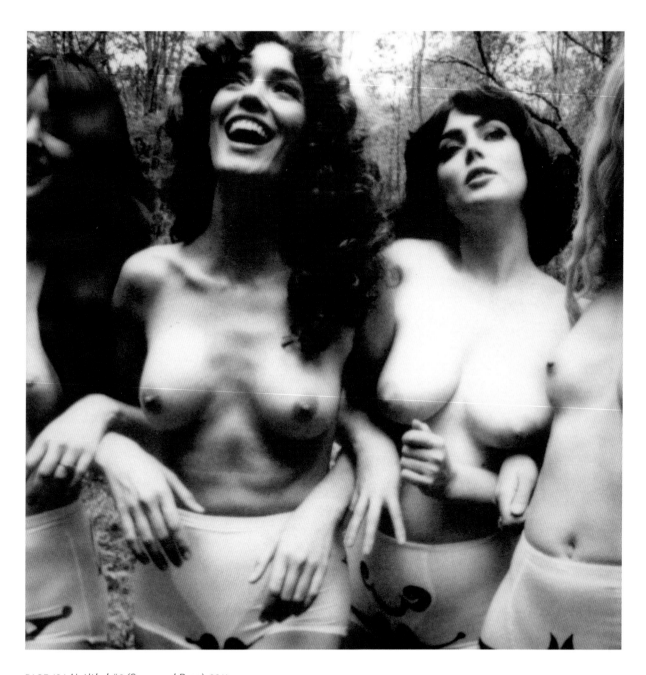

PAGE 134 *Untitled #6 (Snow and Rose)*, 2011
PAGE 135, TOP *Untitled #2 (In Despair)*, 2011
PAGE 135, BOTTOM *Untitled #11 (Women of Canterbury)*, 2011
ABOVE *Untitled #5b (Women of Canterbury)*, 2011
OPPOSITE, TOP LEFT *Untitled #4 (Andi)*, 2014
OPPOSITE, TOP RIGHT *Untitled #9 (Women of Canterbury)*, 2011
OPPOSITE, BOTTOM LEFT *Untitled #1 (Blondie)*, 2010
OPPOSITE, BOTTOM RIGHT Still from *Murder Me Tomorrow*, 2014

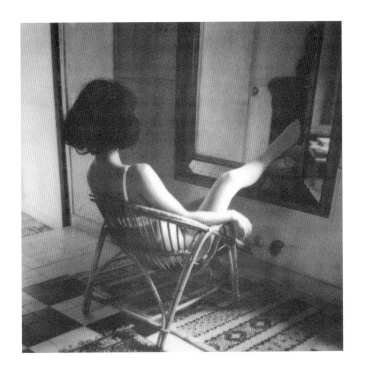

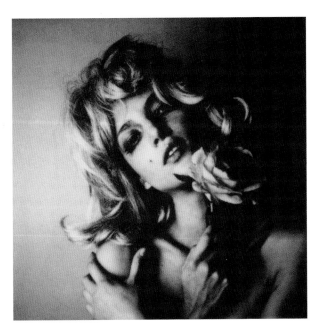

SHAE DETAR

When words fail, there are photographs

When she was eleven years old, Shae DeTar started painting on pages that she had ripped from magazines. Her experiments with photography came much later, in her thirties, but she still employs the technique of painting on top of images, just as she did in her childhood. DeTar didn't formally study art or photography, so, she says, she feels the sense of freedom to create that comes from not having to justify everything she does: 'When I sit down to make a piece of work, I literally free my mind of all expectations from myself or others and I just try and create in the moment ... the way children create.'

In the pervasive culture of the portrait photograph we're living in now, beautiful images of beautiful women can come across as superficial. The way we see images of women online and in advertising, in the media and in films, affects the way we view images of women – and perhaps the way we view women – elsewhere. Images of women, whether experimental, artistic or commercial – or all these things – are ambivalent in the vagueness of contemporary culture: 'All my heroes made really beautiful images of women and were loathed for it at one point or another. Art critics don't bother me ... they are just reacting to what they feel, and I respect that, but I don't let their opinion motivate me or alter my state of bliss in art-making. I really make art for me, and if people like it, awesome ... and if they don't, that's just the way it is.' This romantic ingenuity is palpable in DeTar's painted photographs: 'As Georgia O'Keeffe said, I found I could say things with colour and shape that I couldn't say any other way – things I had no words for.'

DeTar's self-taught and subliminal aesthetic has been shaped by an upbringing being exposed to classical depictions of women in art: 'My heroes in the art field all painted women, and all the art and sculptures I grew up with at home were classical figures of women. My mom always collected antiques, tapestries, statues and murals with these pale, goddess-like women looking like they were out of a dream. I probably subconsciously feel moved by that because it is so familiar, and I have also been obsessed with the 1800s since I was a child ... So, me photographing women the way that I do feels very much like a response to my upbringing. Then on top of all that I *am* a woman, so it's just more familiar to me.'

The decision to depict women means that many viewers come to her work with a political agenda – a critical compulsion where images of women are concerned. DeTar creates a magical reality, a place where her women can exist as they do when she sees them in her mind. 'My aim is not to be controversial or turn anyone on sexually. I just enjoy painting images of women and capturing a classical type of shape of a woman – then it is all about exaggerating the image using paint, to make it something else', the artist explained to me. 'I'm not usually trying to take a photograph of the woman to capture who she is. I'm creating scenery with these women and placing them into a sort of set, a made-up world.'

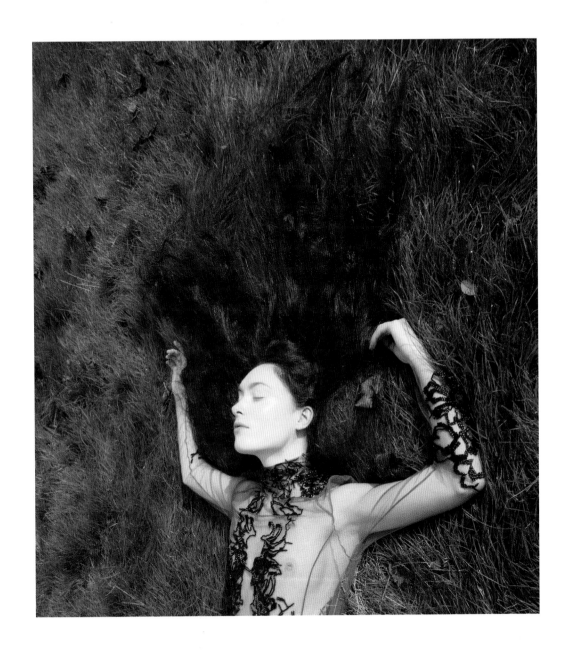

'My aim is not to be controversial
or turn anyone on sexually. I just
enjoy painting images of women
and capturing a classical type
of shape of a woman ...'

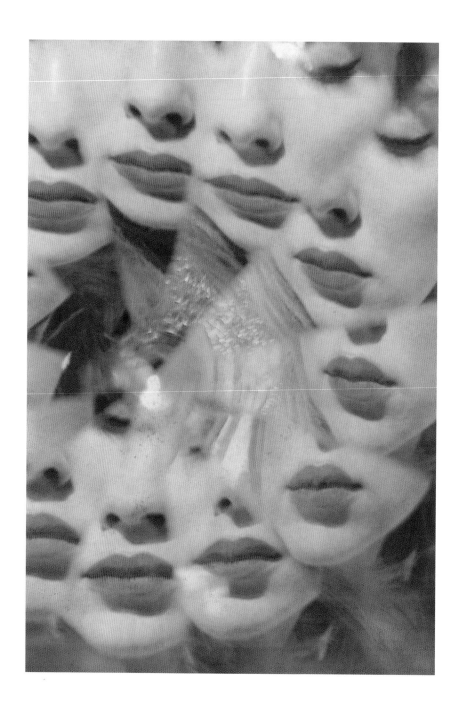

PAGE 138 *Most Imperfectly,* 2014
PAGE 139 *Skye,* 2014
ABOVE *Lips,* 2013
OPPOSITE, TOP *Butterfly,* 2013
OPPOSITE, BOTTOM *Tanglewood,* 2014

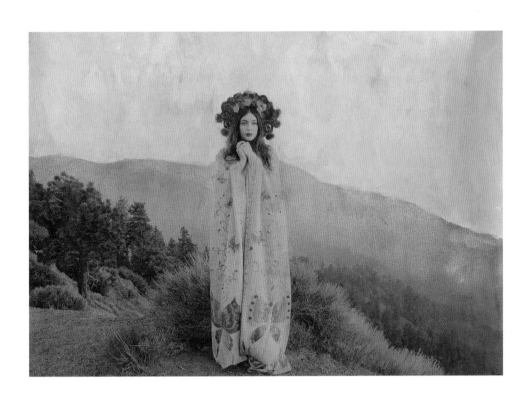

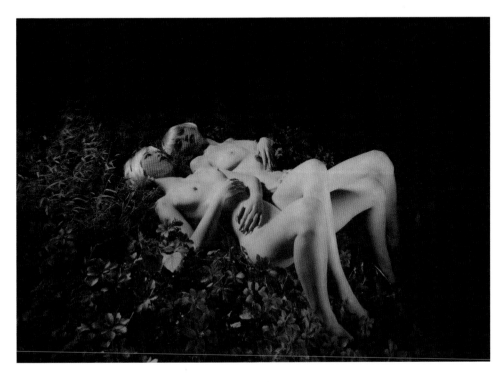

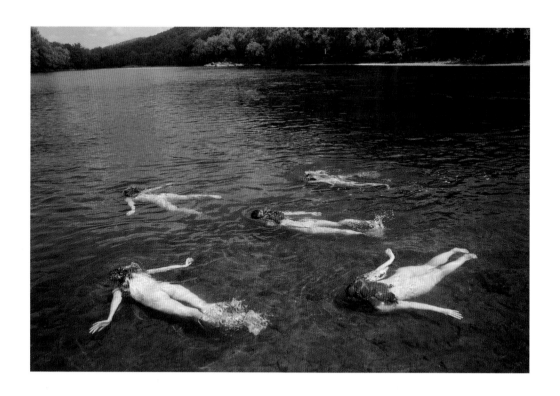

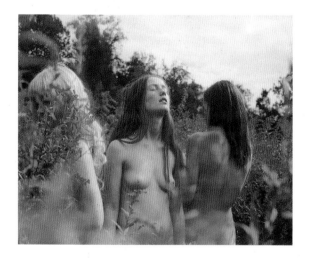

ABOVE, TOP *Another World*, 2014
ABOVE, BOTTOM LEFT *Kensington Gardens*, 2014
ABOVE, BOTTOM RIGHT *The Place I Left Behind*, 2014
OPPOSITE, TOP *Moonlight*, 2015
OPPOSITE, BOTTOM *Free*, 2014

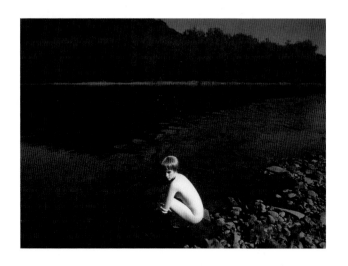

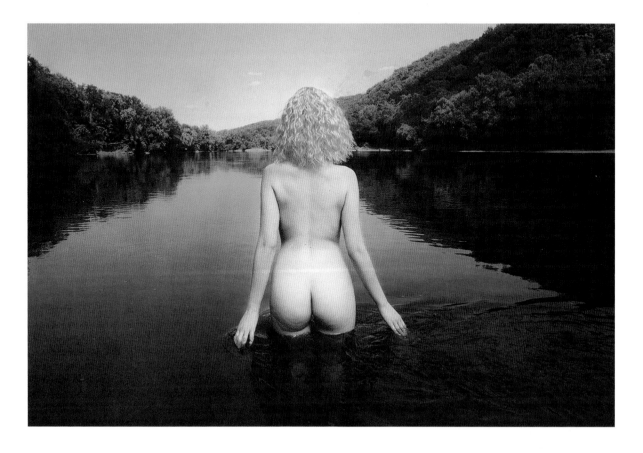

AMANDA CHARCHIAN

The pheromone hotbox phenomenon

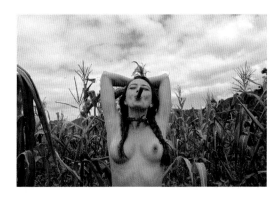

Amanda Charchian is fascinated by the dynamic of a woman photographing a woman. Wanting to explore this exchange in greater depth, in 2012 she began 'obsessively and manically' photographing two young female artists she was travelling with: 'That was the first time I had a conception of a certain power that female artists have that contains a seesaw between sexuality and creativity.' It evolved into a monograph, *Pheromone Hotbox*, published in 2016, that is the crux of Charchian's artistic practice as a photographer. Her framework was to photograph 25 women artists at locations around the world, shooting her subjects against surreal landscapes that were foreign to them. Her subjects would then undress to introduce frisson and movement. Time, place and action informed Charchian's exploration of the symbiosis between creativity and sex.

The resulting images, produced over three years' shooting, are a visualization of the mysterious exchange between female photographer and female subject: 'By delving into the tension, I started to understand that what I was experiencing was exclusive to one female photographing another intimately, in a setting that felt wild both within our mindset and also circumstance. For women the energy of artistic production and sexuality is inextricably linked, most often on a subconscious level. This is what I call "the pheromone hotbox", a space in which a biologically confounded process occurs as our pheromones interact (in a nonsexual way) to generate creativity through simultaneous trust and mischievousness. I discovered that through the camera I had unique access to the creative women around me.

This new-found mode of intimate photographic investigation grew into a project in its own right.'

Charchian's approach has been visibly influenced by her background in painting: she uses colour, light and precise formal aspects of composition to give her photographs their classical feel. Charchian uses a motif of nature to emphasize the secluded solace in which she finds herself with her subjects, far away from the interruption of the urban. Nature in her imagery often also serves as a metaphor that underscores the sexual tension Charchian seeks, but it's a different kind of sexualization than we encounter in male-oriented images of women – Charchian's subjects are at a physical distance and they remain enigmatic, mischievous and confident. The body is only a physical starting point from which a female aura emanates.

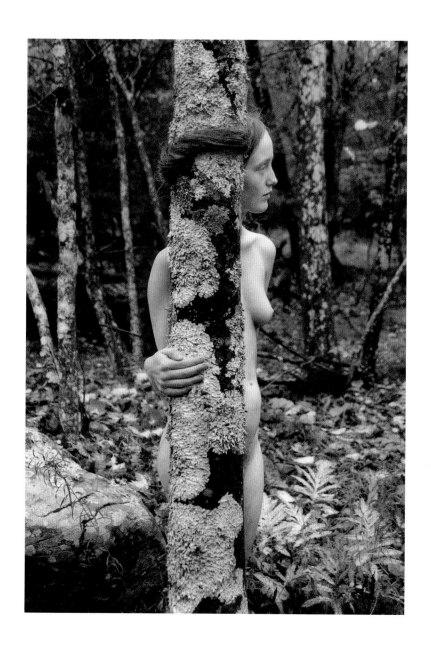

'For women the energy of artistic
production and sexuality is
inextricably linked, most often
on a subconscious level.'

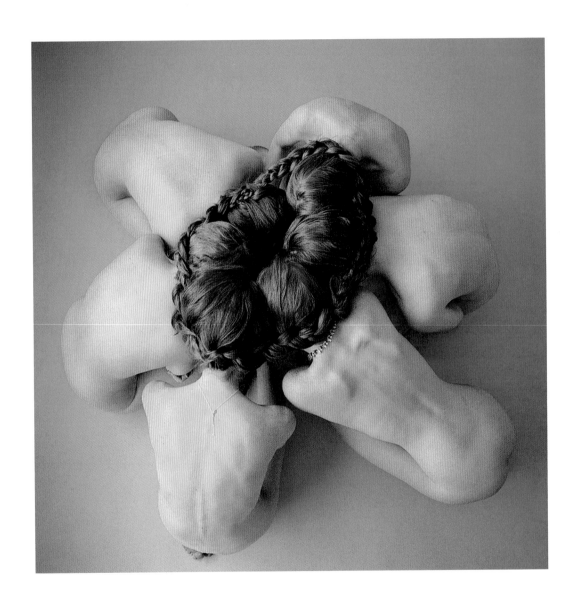

PAGE 144 *Fabianne in Cuba*, 2015
PAGE 145 *India in Woodstock*, 2013
ABOVE *Ginger Entanglement*, 2013
OPPOSITE, TOP From *Ana in Costa Rica*, 2012
OPPOSITE, BOTTOM From *Las Pozas*, 2015

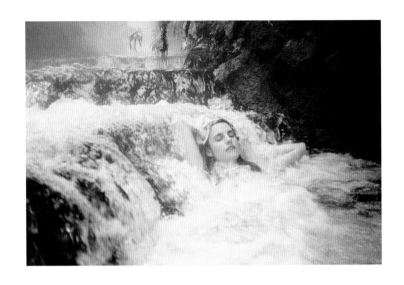

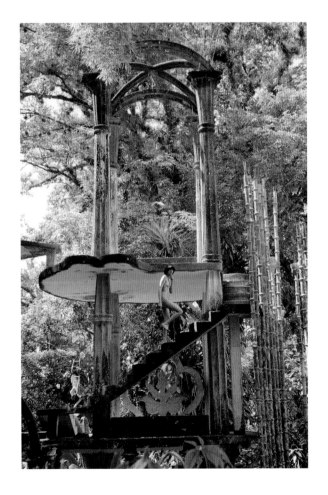

LEAH SCHRAGER

Pay the nipple

Rebecca Schneider writes in *The Explicit Body in Performance* that our responses to any manipulations of the (naked) female body in art are unavoidably mediated by the dominant mode of cultural consumption. Leah Schrager sees the capitalist economy as the determining factor in reading manipulated (and manipulative) images of women's bodies. 'Further, since an art object also exists in this capitalist structure (it is given a price, and a collector can buy it for a price), there's an interesting relationship being articulated between a woman and an art object in relation to the current economic system', she explains.

Schrager articulates the relationship between an object-based economy and the female image in her work by creating mimetic commercial structures: she performs the role of the prototype 'sexy female' to attract different kinds of online consumer. 'Traffic is funnelled online around commerce, sexy women, clickbait, products. I'm really interested in how all these things interact and complicate each other: the notion of art, contemporary pop art, the role of the surfer, art appreciator, consumer, audience, fan. The interaction and social practice nature of being online is really interesting to me.'

In Schrager's net performances, digital paintings, 'infinity' and 'meta' selfies she objectifies herself – as a naked therapist, Sarah White, as a glamour model, or as a celebrity persona named Ona. Her works take charge of her image and her body as a monetary power, embracing self-commercialization as an expression of female agency. 'A woman's body carries inherent value, and choosing to "cash in" on or charge for that value in different ways is a very interesting process to me. Different bodies carry different values in different scenarios, so this isn't new, but for women to be openly charging in such public ways and in such vast numbers is indeed new.'

An example of her drive is her 2015 campaign #PaytheNipple (a riff on #FreetheNipple), initiated by Schrager to promote the idea that women should be properly renumerated when their bodies are used to generate profits: 'For me what's worth discussing is the discrepancy between how we treat industry-sanctioned women and DIY women who are basically doing the same thing. If a woman is working through an institution such as a modelling agency, we revere her. Yet if she does the same things independently, in the form of "posing, playing, presenting", she's often demeaned.'

At her New York exhibition, *Profit Positive Pu$$y* (2016), the artist presented her 'celebrity project' – an alter ego she hopes to turn into a real-life celebrity, tapping into the age of the digital celebrity where anyone can become internet-famous. Schrager sees the potential in this, and her aim, she elucidates, is to encourage acceptance of women who want to profit from their own image or body by using these online channels. She envisages this as a movement 'that accepts the inherent value of female nudity, that takes into account that men and women are different in their desires for sexual interaction, that supports women who monetize what is valuable about their naked bodies and supports men in paying for access to them, that promotes a sex-healthy society by respecting arousal, and that does not glorify nominal actions that empower giant corporations to the detriment of regular working women.'

'Traffic is funnelled online around commerce, sexy women, clickbait, products. I'm really interested in how all these things interact and complicate each other ...'

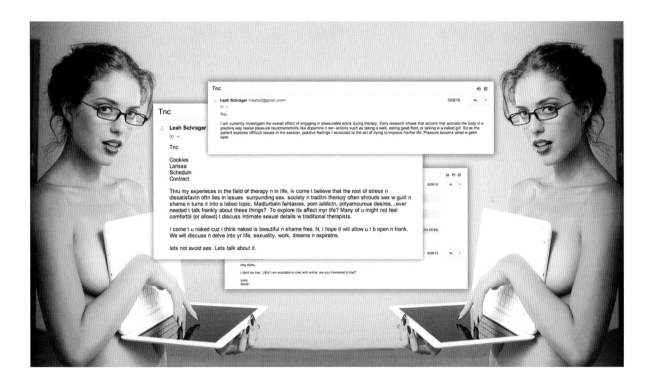

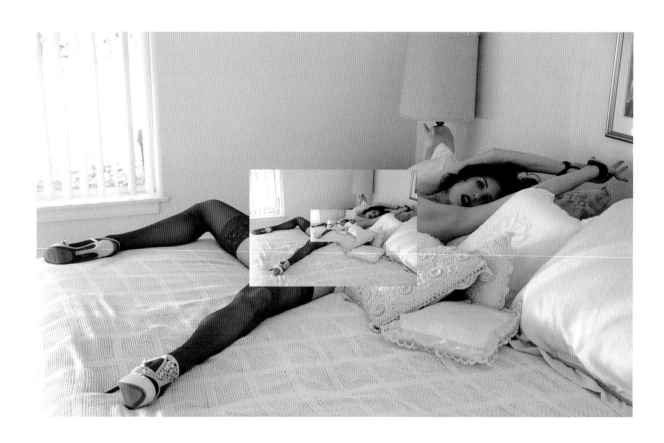

PAGE 148 *Barcode I*, 2014
PAGE 149 From *Naked Therapy*, 2010–16
ABOVE & OPPOSITE *Infinity Selfies*, 2016

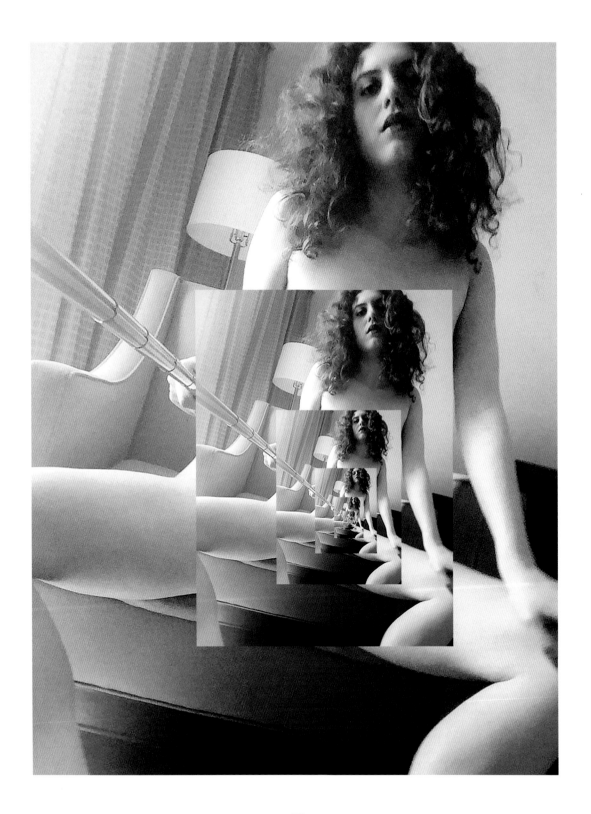

ALEXANDRA MARZELLA

Be your own muse

A lot of the discussions about photography today focus on the way in which Instagram and other social-networking platforms have affected the medium. Launched in 2010, the photo and video sharing app has undoubtedly had a powerful impact, too, on the way women photograph themselves, and on how images of women are seen. In tandem, the front-facing camera (which also came into widespread use in 2010 with the iPhone 4) has equally changed the dynamics of picture-taking, the camera more like a diary of the evolving self-image.

Alexandra Marzella developed her practice on Instagram. Her art is easy to attack: a large part of it is an ongoing documentation on her social media accounts @artwerk6666 (she has had numerous accounts deleted), and it does not fit with what is conventionally considered to be art. Marzella's Instagram, a kind of visual sketchbook of the artist's life and ideas, presents a paradox: the independent, pro-female, pansexual, anti-conformist photos and videos she posts belong to the discourse of contemporary feminism, but her appearance and behaviour still appeal to the conventional ideals of the heteronormative gaze.

'One might say I'm lost in my privilege', Marzella tells me, with the same irony that characterizes her posts. 'Sometimes I think about how a lot of my followers are probably men who think I'm attractive. It's too bad but not surprising.' She says of her online presence, 'I purposely try not to take it seriously. However, Instagram is something I've grown to utilize for many different things.' I tell Marzella that I often feel bad about my own image after looking at her pictures – it might not be her intention but I'm sure I'm not alone. 'I'm sorry you feel that way. Unfortunately the jealousy issue, the constantly looking at curated images of selves, can be so hypnotizing it often leads to serious insecurities.'

Marzella's work brings out these profound contradictions in the larger systems that affect women. Instagram is fundamentally another tool of capitalism: it breeds competition for number-driven popularity, and the stakes are high. Marzella's work seems to ask, what do you want from women? In the reactions her work receives, the inextricable connection between photography, feminism and capitalism in our time is evident. Is it possible to depict a female body in a photograph today and truly liberate it from its profit value?

Marzella is definitely aware of being watched: when she performs for her own camera, she performs for her anonymous audience too. She harnesses the value of her own image in unexpected ways: she is sexy, outspoken, anxious, funny, sharp, strange, self-involved – but importantly, she is in control of the image. We often see her positioning her lens or holding her camera to shoot. It is not absolute truth, but it is sincere: 'I believe in both reality and fantasy. I believe we're all perfect and always have been and will be.' In one of her images, female genitalia, covered in a raw, red, rash, fill the frame. Text is printed in very small writing across the labia – Marzella makes you go up close. 'If you want the perfect pussy, buy a real doll', it reads.

'I believe in both reality and fantasy.
I believe we're all perfect and always
have been and will be.'

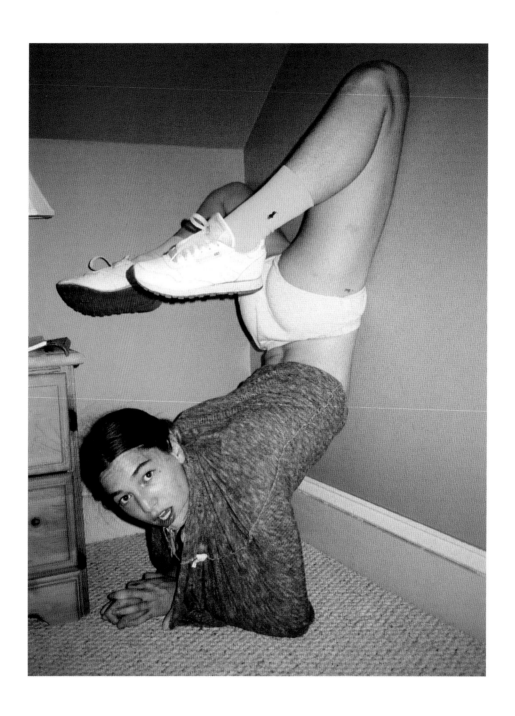

PAGES 152–155 All untitled, 2015

MOLLY SODA

Shame = same

Molly Soda is among the young female artists whose art has come up tangentially after years spent creating self-interrogative images of herself and her experiences and sharing them online. Her lens-based art – made up of videos and photographs, usually shot in her bedroom in Detroit – has, like other female artists working with a similar practice, faced some obstacles in being critically contextualized: 'In general I've struggled with being taken seriously. I've been on the internet since I was a teen, I've been posting about myself online for a long time, so it's been a natural evolution for me. I think people dismiss the work, they see it as shallow, self-involved, or it is brushed aside as corny, or easy, cheap. But the fact that it is accessible – that people get it – shouldn't mean that it isn't considered valuable.'

It's an age-old problem for female artists who work with their own image, but it's even more pronounced now, with the added stigma of online art and selfies. Soda doesn't need the art world for its audiences: the online community she's amassed proves that her work is already significant and she has an influential voice. Her followers probably outnumber most blue-chip galleries and art magazines. Yet the lack of real critical attention means that many meanings are missed, along with many opportunities to understand the worlds of young women now.

Get past Soda's preternaturally teenage aesthetic, and her works discuss a major issue for women, with an acuity that is surprising for Soda's twenty-something years. Shame – how women experience it and how they can defeat it – is at the core of Soda's practice. Since Western tabloid media – hand in hand with corporate advertisers

– began to publicly shame women by publishing 'candid' images of them, a way to feed that capitalist machine which thrives on competition, women's private lives have become a spectacle, used to shock, sensationalize and sell. Nudes have been leaked, sexts have been published, and close-ups of cellulite have been pasted over centre spreads. For some women, the internet is an even greater source of anxiety – a place where self-image becomes vulnerable.

Soda's work turns shamefulness into sameness. The series *Should I Send This?* (2015), in which Soda released her own private, sexual pictures, is a direct response to the culture of shaming women through their private activity. Another standout work, *Caught* (2015), represents an ongoing interest of the artist, the paparazzi – the enemy to privacy in the modern world. While the artist appreciates the aesthetic qualities of the paparazzi's zoomed-in photographs – washed-out colour, slightly blurred focus – her staged version, a photograph of herself voraciously eating a sandwich in her car, defangs the photographer who tries to catch their subject out with the implication that their behaviours – or their bodies – are embarrassing. The paparazzi picture is turned into an expression of agency: 'Everyone feels embarrassed. My way to combat feelings of embarrassment has been to make things I feel embarrassed of public, so that I own it, I am controlling it. That's been my process. I started to record a lot of the stuff I felt shameful about, texts and images, and to post them, to work through that feeling of shame. The internet helped me to find comfort in sameness, to find people who cared about the same things. That collective nod was a way for me to not feel so alone.'

'Everyone feels embarrassed. My way
to combat feelings of embarrassment
has been to make things I feel
embarrassed of public, so that I own it,
I am controlling it.'

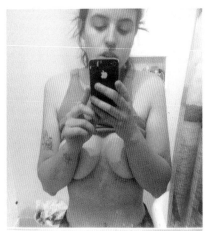

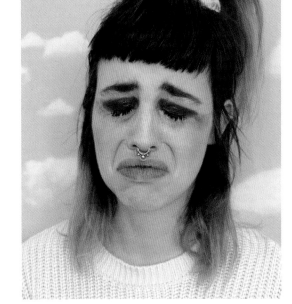

PAGE 156 *Inbox Full*, 2012
PAGE 157, TOP *Our Song*, 2015
PAGE 157, BOTTOM *Mad About U*, 2015
ABOVE, TOP & LEFT From *Should I Send This?*, 2015
ABOVE, RIGHT Untitled, 2015
OPPOSITE *Caught*, 2015

PETRA COLLINS

Girl culture in the 2010s

Petra Collins is for mainstream US youth culture in the 2010s what male predecessors (and mentors) Ryan McGinley and Richard Kern were for their times – photographers who have captured the aesthetic and ambience that define their generation, by being part of it. Since the age of fifteen (Collins was born in 1992), she has been documenting herself and her friends – the first generation to grow up in the internet image culture – on 35mm film. Her candy-coloured photographs, soaked in post-pop sentimentality, aestheticize the growing pains of female adolescence in the West.

Collins's medium is her message. Her shoots are like teen therapy sessions: the artist emphasizes collaboration, so her models also act as technical assistants and Collins encourages talking openly and freely during shoots. Her portraits of teenhood and their representation of feminism might seem literal to adults, and her work is often consumed by the exact same structures it criticizes (the fashion industry, advertising, the media), but the content of her photographs is perhaps subordinate to the community she has built through them. The way of seeing online is instantaneous, structured to 'like' and swipe quickly on. In digital space, meaning is made through fast-flowing streams rather than single snapshots. Collins's output insists on visibility via accumulation, organizing group exhibitions and publishing a book and zines of young female art, writing manifestos, designing clothing, shooting spreads for cult youth magazines and making all-girl short films, all alongside her own girl-centric photographic work.

Collins uses her own image, celebrity and online platforms (she's a contributing photographer at *Rookie*

magazine and runs an all-girl art collective, The Ardorous) to interpret feminism for a new generation of young North Americans and talk about the issues affecting young girls, such as shame, periods, acne, body image, sex, sexuality and mental illness, in a way that those girls can relate to them. She might not speak for everyone, but her influence can't be ignored: she's present everywhere from social-media feeds to catwalks and commercial magazine covers and her audience is her validation.

Headline controversies have punctuated Collins's work to date, proving how the topics she addresses are still co-opted and sensationalized. In 2013, she designed a t-shirt for American Apparel depicting a menstruating vagina in a masturbatory position. It reignited the 1970s campaign of French radical feminist writers Marie Cardinal and Annie LeClerc, who rallied against the control mass media and advertising exert over women's bodies, coining the term 'tampaxification' to refer to the concealment of depictions of menstrual blood in tampon adverts.

Later that year, a picture Collins posted to Instagram of her unshaven bikini line resulted in the social-media platform deleting her account. In response she wrote at the time, 'I'm used to seeing female bodies perfected and aspects concealed in the media (i.e. in hair removal ads for women hair is NEVER shown).' Both events provoked wide public debate, raising Collins's profile but also proving how radical the reactions to women's bodies are. The controversy demonstrates that, despite apparent progress in how we view women's bodies, they continue to be policed, controlled and censored, and there is much work to be done.

'I'm used to seeing female bodies
perfected and aspects concealed
in the media (i.e. in hair-removal ads
for women, hair is NEVER shown).'

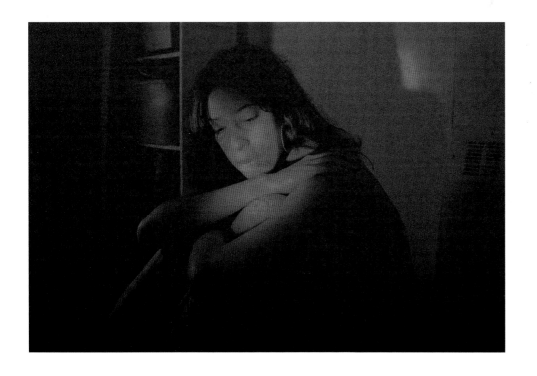

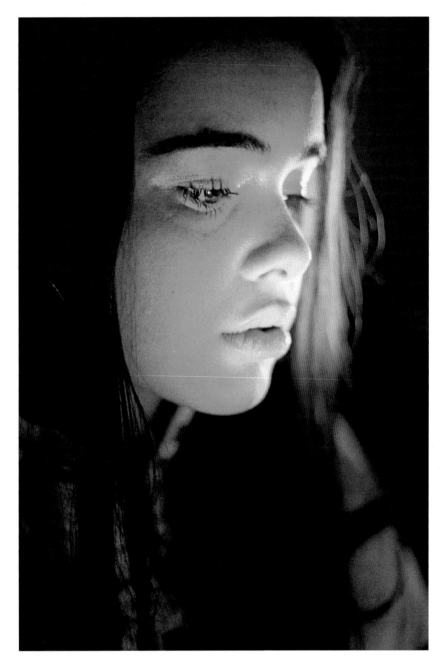

PAGE 160 *Untitled #23 (Selfie)*, 2013–16
PAGE 161, TOP LEFT *Untitled #15 (24 Hour Psycho)*, 2016
PAGE 161, TOP RIGHT *Untitled #17 (Selfie)*, 2013–16
PAGE 161, BOTTOM *Untitled #28 (24 Hour Psycho)*, 2016
ABOVE *Untitled #31 (24 Hour Psycho)*, 2016
OPPOSITE, TOP *Untitled #25 (24 Hour Psycho)*, 2016
OPPOSITE, BOTTOM *Untitled #07 (Selfie)*, 2013–16

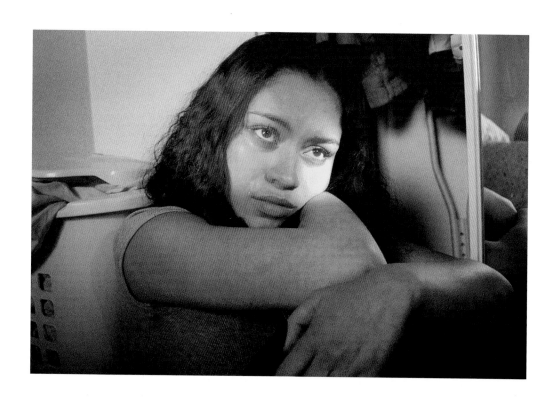

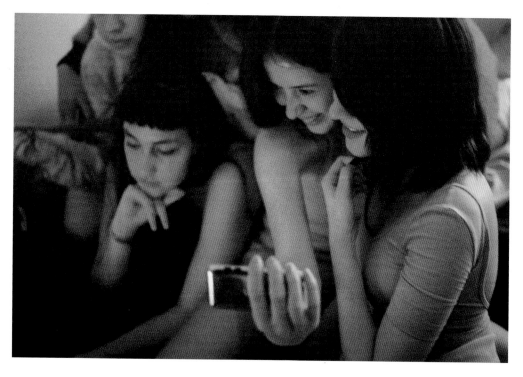

MAYAN TOLEDANO

Feminist knickers

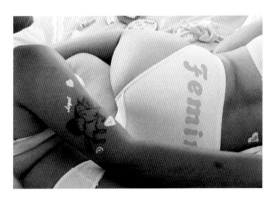

Valerie Solanas – the most radical of feminist writers – wrote in her controversial manifesto, *S.C.U.M.*, that women have an impulse to 'create a magic world'. While Solanas's idea of a feminist utopia in the 1960s on the surface seems very far from Mayan Toledano's rebranding of feminism for 21st-century neoliberal teens, the photographer shares a desire to create a 'magical' all-girl space in her coming-of-age snapshots, mostly created for her platform and brand, Me and You: 'We wanted to start something that felt more inclusive, safe and inviting, more celebratory of our girlhood and femininity. In fashion school I was expected to neglect my girly playfulness in order to be taken seriously and I disagreed with that. I think that by creating female-centric work as a female I already have a better understanding of my subjects. I hope that the images I create through the lens of Me and You help make girls feel good about themselves. I'm always looking for new ways to tell stories, and what is mostly important to me is to find new ways to look at what isn't seen as much.'

Toledano grew up in Israel in the 1990s but her work has resonated most in the USA (where she now lives), the heartland of pop suburbia. Her photographs riff on the iconography of suburban girlhood – hair scrunchies, lollipops, glitter-kitsch, heart stickers, dungarees, saccharine colours – derived from hit '90s US TV shows and iconic teen films of the era by John Hughes and Sofia Coppola. Through her hyperfeminine aesthetic, Toledano conveys a belief in neoliberalism, multiculturalism and the power of self-love: 'What is so great about the space we share online today is that it allows us to creatively speak and express ourselves individually and as a group.

Finding each other online as a community makes us feel less alone. Without having to be that one-tone female that is usually represented in mass media, we are the ones setting new boundaries by communicating images online. We live in an image-based culture but we are constantly bombarded with ones that don't match our stories or our real experiences as women. On the internet, on the other hand, we are able to show our imperfections, to love ourselves, to be sexual, hormonal, vulnerable, etc. We find new ways of solidarity and we support each other. I consider any form of female exposure empowering and feminist as long as the creator considers it to be, as long as she feels safe and empowered by it.'

However, Toledano's images – and her clothing line, featuring knickers emblazoned with the word 'feminist' – have enflamed feminist critics. While they do make a politic a commodity, it's easy to forget who their intended audience is, and the positive influence the work had on hundreds of thousands of young female fans following Toledano: 'I find comfort in knowing that more girls feel the same way as I do, wanting to break free from what our femininity is expected to be, disagreeing with how our sexuality has been manipulated. There is a strong movement of girls on the internet reclaiming their sexuality and owning it in a way that is personal to them. Me and You is in every way part of that movement, trying to deliver a modern idea and representation of today's youth culture and female culture in general.'

'What is so great about the space
we share online today is that
it allows us to creatively speak and
express ourselves individually
and as a group. Finding each other
online as a community makes us
feel less alone.'

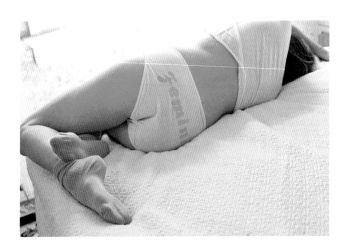

PAGE 164 *Mada and Kalale, New York,* 2015
PAGE 165 *Lulu, Ali and Sofy, Long Island,* 2015
ABOVE, TOP, & OPPOSITE *Yani, New Jersey,* 2015
ABOVE, BOTTOM *LA Girls,* 2015

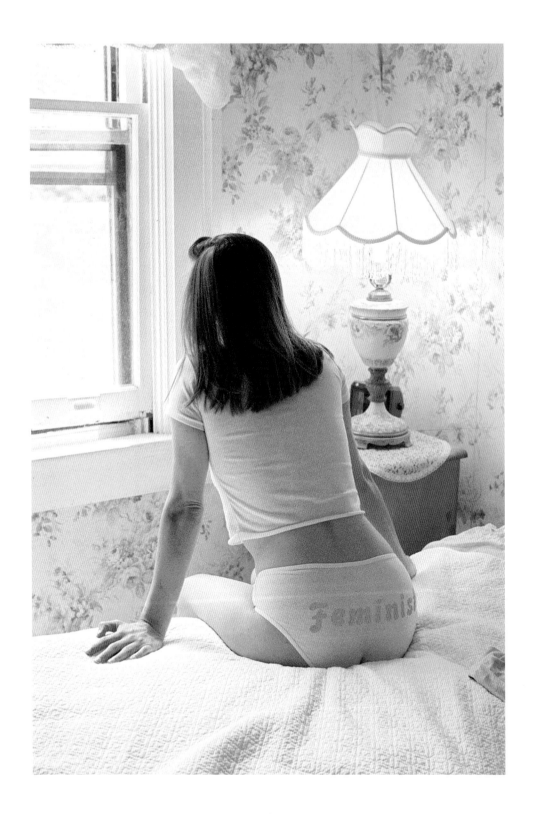

MONIKA MOGI

Kawaii and pink collars

'I started to realize only recently that I have the power to change Japan', Monika Mogi tells me. 'Mainstream advertising in Japan does not empower women; it seems as if not much thought goes into the casting – they just look for a girl who is "kawaii" [cute]. I look for a girl who has something to say and isn't afraid to stand up for what she believes in. It is a very difficult part of Japanese culture that I have a hard time understanding, but in Japan people tend to not bring up big issues such as feminism.' In her 2015 project *Fuck OL Culture*, Mogi addresses a specific example of this, challenging Japan's 'Office Lady' (OL) culture, which encourages women to pursue menial professional work, or 'pink collar tasks', to boost the morale of working men.

Mogi grew up as an only child to a single working mother and her first encounters with photography were on the internet at the age of twelve. She doesn't feel she belongs in the culture of a country, but the culture of images she found online had a magical effect on her. In Japan, Mogi's fashion work stands out, with her diverse cast of subjects who do not give one idea of beauty: 'My casting is very important. There tends to be a lack of different body types shown in Japan.' But it's not only Mogi's choice of models that subverts fashion photography conventions – her models are often shown smiling and laughing: 'My whole goal is to promote female positivity and confidence.'

In 1967, photographer, curator and critic John Szarkowski referred to a 'double standard', whereby photographers consider commercial work less important or interesting than their personal or artistic work. Perhaps the distinction is not relevant at all in the digital image age –

commercial photography now is an opportunity to expose different kinds of images and ideas of women, and to a far wider audience than a museum: 'With the internet we control which women we want to bring up and make known. I think with the power of the young generation we are going to change more and more! Social media is making real girls more popular and more visible than models.' Does it matter if a woman is behind the lens? 'I have never branded myself as a female photographer, I have always wanted to be seen as just a photographer', Mogi explains, but she admits that the exchange between women is different because she can relate to her female subjects, and vice versa.

A converse effect of the increasing number of female photographers is that the media is taking more interest in the women behind the lens than in what is produced in front of it. Mogi's own experiences suggest that deeper collective attitudes towards female artists still haven't caught up with the ideas that women project through their work: 'The problem I have experienced recently is if you are kind of attractive and a female photographer, brands will try to use you as a device. I don't know if I agree with this. Once I was asked to take part in a shoot for a major clothing company. I was excited to be asked, but I then discovered they wanted *me* to wear the clothes and take a self-portrait. Why? My talent is in taking photographs, not modelling. If I were a normal-looking guy, would I be asked to take a self-portrait for a campaign? Maybe, but the odds are against it … I don't want people to know too much about my appearance or me. I just want people to feel something from my images.'

'My casting is very important.
There tends to be a lack of different
body types shown in Japan.'

PAGE 168 *Taka and Sayaka, Harajuku,* 2014
PAGE 169, TOP *Effy in Beijing* (for American Apparel), 2014
PAGE 169, BOTTOM LEFT *Sayaka crying, smoking cigarette,* 2014
PAGE 169, BOTTOM RIGHT Editorial for *The Editorial Magazine,* 2015
ABOVE & OPPOSITE Kiko Mizuhara and Nana Komatsu, fashion editorial for *FREE Magazine,* 2016

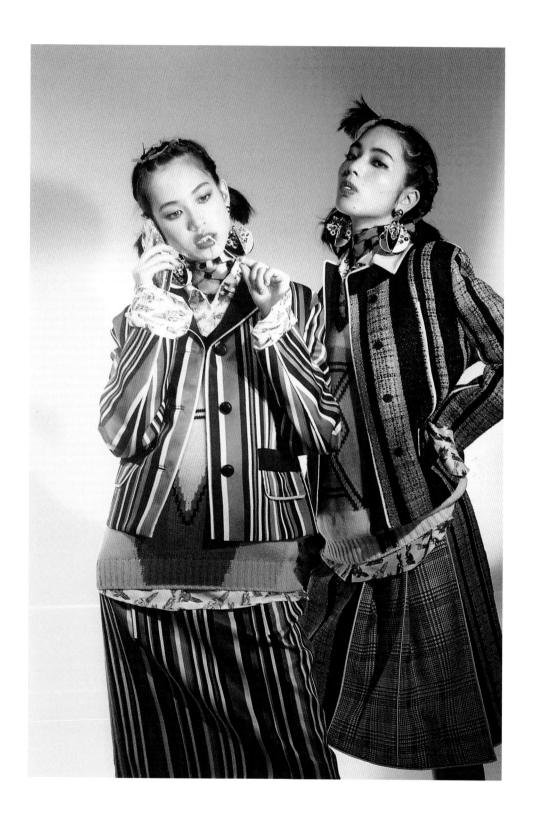

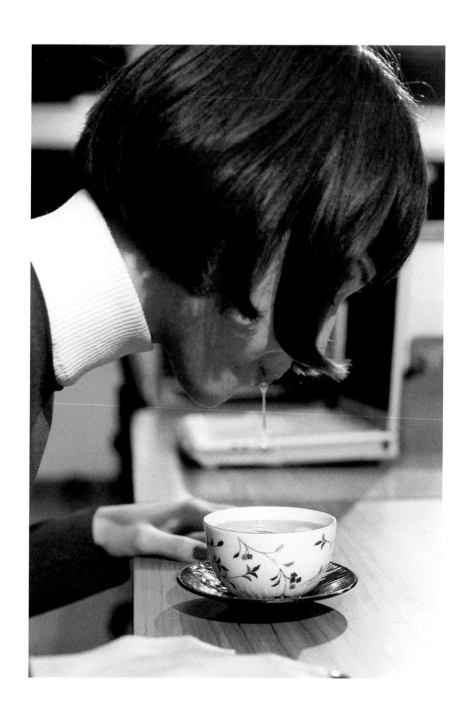

ABOVE *Fuck OL Culture*, 2015
OPPOSITE Editorial for *The Editorial Magazine*, 2015

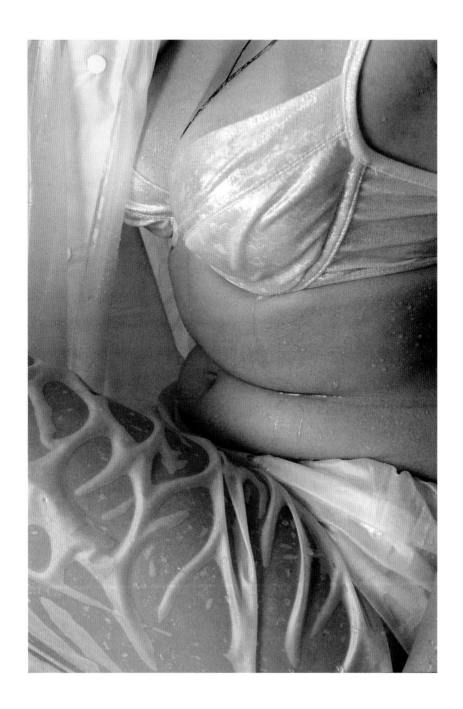

ELIZABETH RENSTROM

Princess culture, fan girls and cyberpunk

As an artist and a photo editor Elizabeth Renstrom has a dual insight into the industry of images. She explores the way gender-coded images in both self-generated and corporate mass media (films, magazines, social networks) are appropriated by young people and deviate from their intended meaning. In her photographs, Renstrom negotiates these ideas on sexuality and gender by looking at the cult aspects of teenage imagery, the personal space and the way girls use posters and photographs to mediate their identity in surprising ways: 'When I was an undergrad I began asking questions about how girls craft their identity and why we are drawn to certain symbols from a young age (dolphins, horses, etc.). I had been reading Peggy Orenstein's book *Cinderella Ate My Daughter* and became fascinated with Princess culture and how aggressively it's marketed to girls, and how that manifests in weird ways from childhood to the tween years.'

In an early series, *Lisa Frank Blues*, a scrapbook of high school memories, Renstrom explores different forms of personal ritual and ceremony – diaries, mirrors, phones, posters and magazines – as a search for identity. In one image, an entire bedroom is plastered with pages ripped from magazines: 'I was taking an extreme look at a popular form of self-expression among teen girls: the magazine collage that you find on cork boards, a mash-up of cuttings from glossy magazines and fashion books. I built out a mini-bedroom underneath my own lofted bed and plastered everything in models, sayings and make-up imagery. It's another way of girls looking towards specific media to inform them on how to live. This is what it looks like when your entire personal space becomes an inspirational shrine.'

In another image, a girl stands in a sanctum of posters, dressed as the character Leeloo from the movie *The Fifth Element*. Renstrom explains: '*The Fifth Element* was one of my favourite movies growing up. To me, Leeloo was perfect and I wanted to look like and be her, despite my pudgy twelve-year-old figure. The photo talks about someone who might not be considered "perfect" by the extreme beauty standards placed on women, but she is worshipping to Leeloo as an icon to aspire to.' Mass images don't always work perfectly, but for Renstrom new meanings can be created by the way an individual relates to them.

Other allusions to the ritualistic and occult use of images in teen/tween representation appear in a later series, *Waxy Chunks*: 'When I was younger I used to keep a very active live journal, cataloguing all my after-school thoughts and building relationships online because I was a pretty dweeby tween and didn't have a lot of IRL friends. This was in the early 2000s, when screamo/emo was becoming a huge trend and kids online would post really melodramatic lyrics or write their own angst-filled poetry. I cringe thinking about it, but when you're that young all your emotions are extreme. I like to poke fun at the melodrama in the work I make now.'

Renstrom concedes that the teenage bedroom detritus and fan-girl paraphernalia that feature in her works are specific to growing up in the West in the late 1990s and early 2000s. 'I don't deny that the symbolism and aesthetic of my wacky constructions are made for people who grew up around the same time I did, but I'm fine, thrilled even, with people reinterpreting or getting something different out of the work.'

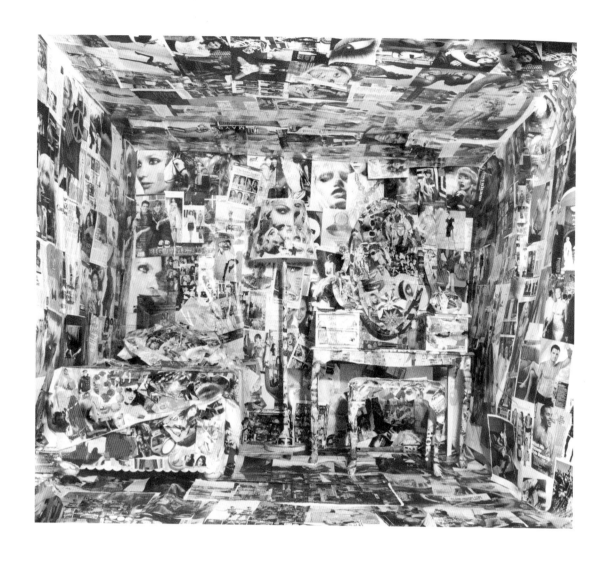

'I became fascinated with Princess
culture and how aggressively
it's marketed to girls, and how that
manifests in weird ways from
childhood to the tween years.'

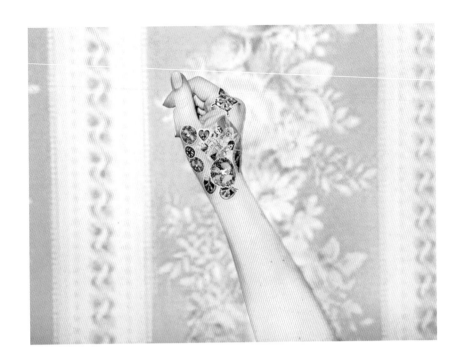

PAGES 174–177 All from *Lisa Frank Blues*, 2012

MAYA FUHR

'Be sexy if you want to be sexy, take a selfie if you feel sad'

'I'm lucky to exist in this time when young, female artists are being praised for their work', says Maya Fuhr, whose work mixes documentary, fashion and portraiture photography, playing with the aesthetics of androgyny, femininity and the internet. She often shoots her subjects in a realistic style, ruptured by extravagant outfits, unusual props and backdrops that give the feeling of play and fantasy. As a regular contributor to youth culture magazines, including *The Editorial Magazine*, *Nylon*, *Vice*, *Dazed & Confused* and *Oyster*, it's the world through the eyes of an image-led generation: 'In my work I explore Tumblr culture by thriving off the vast audience and never feeling judged for what I'm putting out there. Tumblr makes girls feel comfortable about feeling sad or lazy, because it's a community of billions of people scrolling and sometimes longing for the idealized view of beauty that they see. It's highly relatable to hear other people's problems or see a wide range of beautiful body types and ethnicities lying on their bed, on their computer, alone.'

Fuhr is aware of how her work might be perceived and read against its intended effect, but she tries not to let it discourage her in her creative process: 'I shoot all kinds of people and it's rarely about beauty. I'm inspired by people who are comfortable in their own skin, regardless of gender or shape.' Often discussions on pro-women images made by young women assume that these images have a positive effect, but we do not yet know how they will impact on the next generation – the first generation to be raised on a prolific image culture – into adulthood. Reports have shown that women are far more susceptible than men to feel unconfident about their body and unhappy with

their self-image. It could be linked to the fact that we see far more images of women in circulation, and many of those images of women that we see on a daily basis – including some of the images Fuhr produces – feed into a system that exploits this vulnerability: 'I know that my fashion work subconsciously can affect viewers because the image of the model is unrealistic and at times way too thin. The fashion world is a fantasy world I love, but it provokes feelings of insecurity and frustrations because it's generally promoting unrealistic body types and social classes. I can only hope that people have viewed my fashion pictures as artistic and unconventional, and know that the clothing looks good on anyone who is confident in themselves. I love shooting normal girls in fashion stories – more than thin models – but unfortunately that's not always what the designer or client is looking for.'

Fuhr believes that, ultimately, continuing to photograph women, regardless of the industry and the media, is important in building diverse ideas around sexuality, creativity and the self: 'If you watch modern-day movies or TV, or read mainstream magazines, sexism still exists. The female body should not be sexualized for merely being present.' This is what for Fuhr constitutes girl power in the 21st century: 'Be sexy if you want to be sexy, take a selfie if you feel sad. It's "in" right now and will be forever – we're continuing to flourish as creative, beautiful creatures.'

'I'm inspired by people who are
comfortable in their own skin,
regardless of gender or shape.'

PAGES 178–181 All untitled, 2013–16

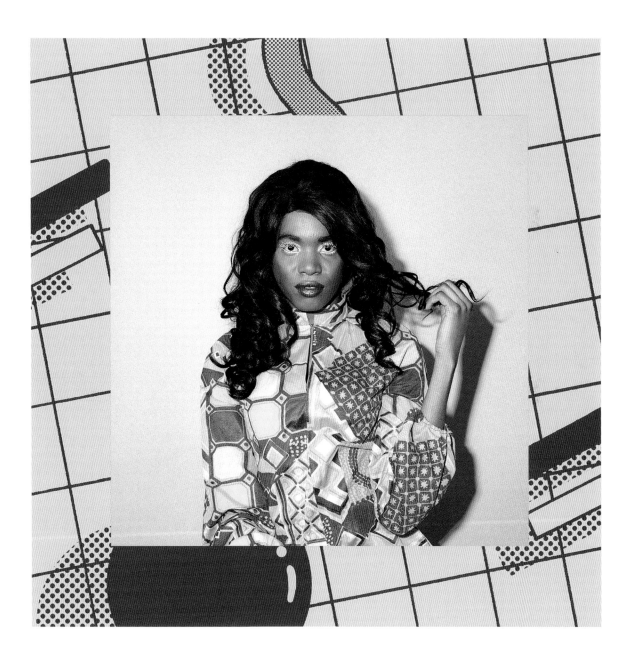

JESSICA YATROFSKY

See what you want to see

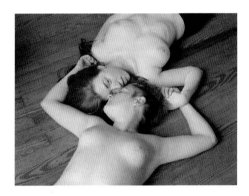

In recent years a persistent question asked of female photographers who photograph women is whether the women who are photographed are a fair representation of women in general. Of course, they cannot be. Yet female photographers who make pictures of female subjects have been required to address this issue very directly. We seem to expect women artists to provide diverse, well-rounded images of *all* women, or of certain groups of women. Men, meanwhile, have been free to create idealistic and unrealistic images of women since the camera was invented.

But female artists – including female feminist artists – do not often claim to represent *all* women through their art. Jessica Yatrofsky's work does challenge the popular female representations in the mainstream: she often uses the staging of fashion magazine editorials but reinvents it with her own models, naked and barefaced. None of her images are Photoshopped or digitally touched up, and she works with women whose bodies do not fit with the cis white feminine prototype preferred by the beauty industries. Her aim is not to represent *all* female bodies; she depicts the women in their bodies, women from her social circle, close friends and acquaintances. They are bodies she feels connected to – and attracted to: 'I have a type I photograph in my work – I have to make my work based on my own desires. Sometimes my models turn into my type through my lens. I don't think the subjects I shoot are perfect, but they're perfect for *me*. You have to create your own world, your own fantasyland. My work is not intended to be a survey of women.' Her monograph of all-female nude portraits, *I Heart Girl*, shows that the artist's type is

androgynous, gender fluid, natural. All kinds of bodies are present in the collection of work, but they are seen through Yatrofsky's eyes.

When *I Heart Girl* was released in 2016, it was marketed under the category of 'Art/Photography'. Online, Yatrofsky has frequently faced censorship that declares any nude photograph of a woman as inappropriate content. It's another example of the contradictions in the economic systems that govern the way we see, define and control female – and male – bodies. In one context, we're told the naked female body should be considered 'art', and in another, we're directed that it signifies 'sex'. 'I just have to get over it', Yatrofsky confides. 'I have a website and a Tumblr, and people can access my books to see the uncut, unbridled versions of my work.'

She notes that the responses to her work, though mostly positive, also show how different our expectations are when it comes to images of women. Many female photographers now depict their subjective female experience, but there are systems far bigger – such as the media and the economy – that govern the hierarchy of photographic images. Released into the world and stripped of their original context – the safe, secure and intimate environment Yatrofsky creates for her models – the artist has to simply relinquish control of her work: 'People see them the way they want to see them.'

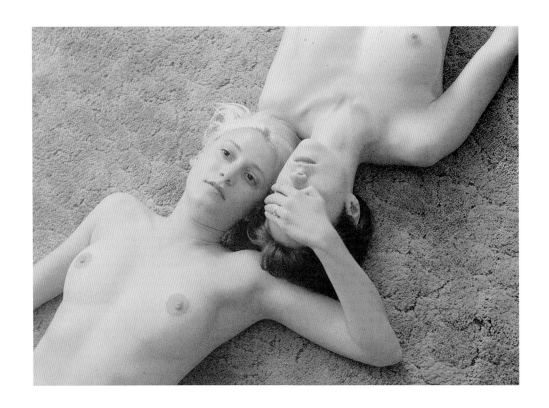

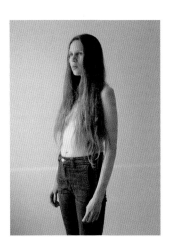

'I have a type I photograph in my
work – I have to make my
work based on my own desires.'

PAGES 182–185 All untitled from *I Heart Girl*, 2007–16

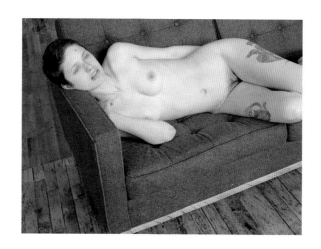

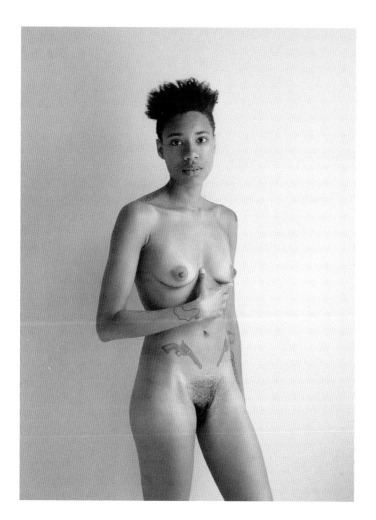

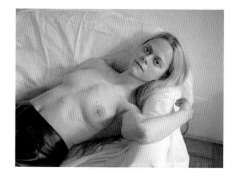

JOHANNA STICKLAND

Pillows and prettiness

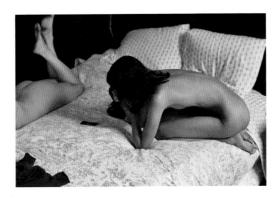

What does it mean to shoot an 'intimate' and 'honest' portrait? These words often come up in relation to new images of women made by women, to describe a photographic aesthetic that rejects retouching, digital manipulation or make-up. But even without artifice, the camera rarely gives us truth. 'I suppose honesty to me is the search to do something that is authentic to my tastes, meaningful in my connection with the person I'm photographing, and unposed to a certain extent', explains Johanna Stickland, who photographs other women. 'I like to be as present as possible when taking pictures and to be lost in the moment without thinking of the outcome. I guess in that way it's an attempt to capture an "honest" moment in time.' Her preferred setting is the bedroom, riffing on a long-established trope in art of depicting women in their interior domestic spaces as an erotic allusion and to demarcate gender. Though she says she does not try to overtly counter these conventions, Stickland's images pick up on the elegiac and emotive qualities of interiority rather than its erotic or sensuous suggestiveness: 'I like the dreamy nature of how a face looks lying on a pillow. I think it's interesting to reveal this intimate space in an image because it makes it feel like you are enveloped in a private scene.' In her scenes there's a sense of innocence and of the admiration the photographer feels for other women.

The way Stickland photographs women has also been informed by the way she was photographed when working as a model in her teens: 'It made me realize how I like to be portrayed in images. When I would try to look pretty for a photo, it felt very forced and left me feeling a bit empty.

I really enjoyed being portrayed in a more contemplative (and sometimes unattractive or unflattering) way. Some early experiences I had with photographers (most of them female actually) made me realize that modelling and photographing can be an active collaboration between two people and can be really exciting. Working with photographers who had more than a conventionally pretty picture in mind was very eye-opening and freeing to me, and it was kind of like acting. Now when I take photos I always really have that in the back of my mind. That's why I always want the people I'm photographing to be completely comfortable and to just be themselves.'

Stickland experienced the adverse effects of being photographed: 'I found it difficult to have my face and especially my body looked at with a scrutinizing eye. I was also very young – fourteen – and more sensitive to other people's criticisms. It took me a long time to get over this but now it's been nearly ten years so I feel like a different person.' Stickland's stint in front of the camera has imbued her work with the impetus to understand and see women's bodies pluralistically: 'I think that showing more sensitive, touching, natural photographs of women is a refreshing and positive thing. I think that it's important to have a wider variety of images out there rather than the very Photoshopped standard fare. I think, if anything, it contributes a different kind of beauty and maybe opens people's eyes or can even empower some women to see themselves portrayed in this different light.'

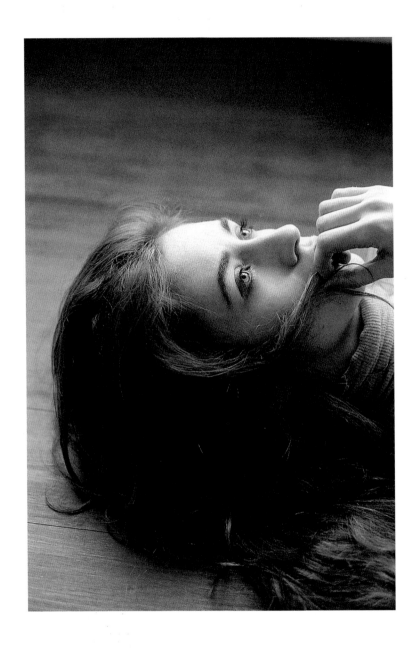

'I think that showing more sensitive,
touching, natural photographs of women
is a refreshing and positive thing.'

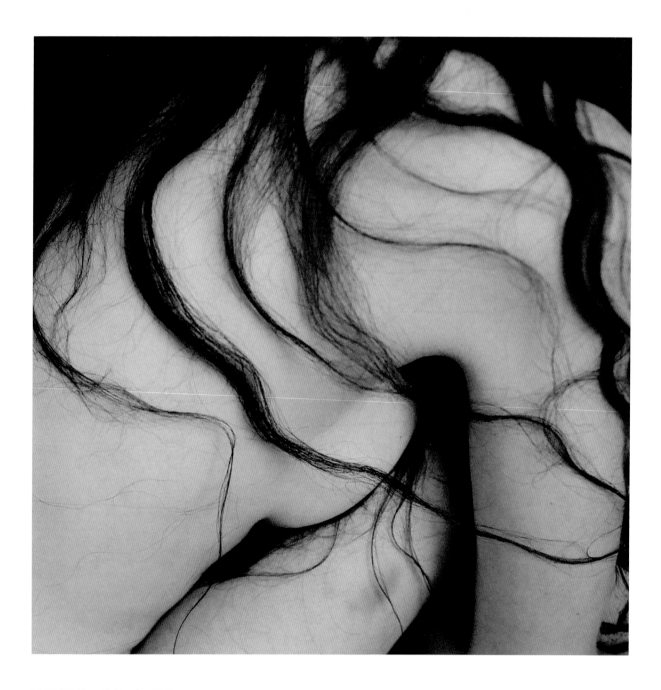

PAGE 186 *Kara & Brooke*, 2013
PAGE 187 *Blue Gaze*, 2014
ABOVE *Tangled*, 2015
OPPOSITE, TOP *Danielle*, 2015
OPPOSITE, LEFT *Peppina Dreaming*, 2015
OPPOSITE, RIGHT *Shadow Portrait*, 2014
OPPOSITE, BOTTOM *Kate*, 2015

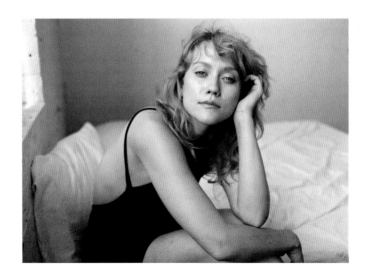

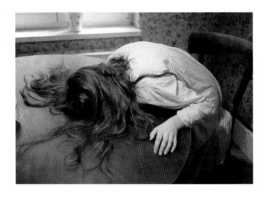

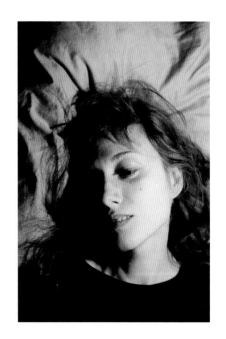

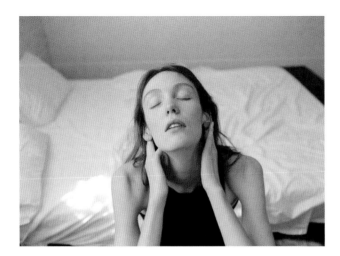

LEAH SCHRAGER (PAGES 148–151)
Works by Leah Schrager
149 Photo Joshua Darling, courtesy of
the artist and Marina Galperina ANIMAL
New York

ALEXANDRA MARZELLA (PAGES 152–155)
All works are digital photos.
Images courtesy of Alexandra Marzella

MOLLY SODA (PAGES 156–159)
Images courtesy of Molly Soda

PETRA COLLINS (PAGES 160–163)
Images courtesy of Petra Collins and
Ever Gold [Projects], San Francisco
160 *Untitled #23 (Selfie)*, 2013–16, digital
C-print, 76 x 114 cm (30 x 45 in). Edition
of 2
161 TOP LEFT *Untitled #15 (24 Hour
Psycho)*, 2016, digital C-print,
165 x 109 cm (65 x 43 in). Edition of 2
161 TOP RIGHT *Untitled #17 (Selfie)*,
2013–16, digital C-print, 76 x 114 cm
(30 x 45 in). Edition of 2
161 BOTTOM *Untitled #28 (24 Hour
Psycho)*, 2016, digital C-print, 43 x 28
cm (17 x 11 in). Edition of 2
162 *Untitled #31 (24 Hour Psycho)*, 2016,
digital C-print, 76 x 114 cm (30 x 45 in).
Edition of 2
163 TOP *Untitled #25 (24 Hour Psycho)*,
2016, digital C-print, 76 x 114 cm
(30 x 45 in). Edition of 2
163 BOTTOM *Untitled #07 (Selfie)*,
2013–16, digital C-print, 76 x 114 cm
(30 x 45 in). Edition of 2

MAYAN TOLEDANO (PAGES 8 & 164–167)
Images courtesy of Mayan Toledano

MONIKA MOGI (PAGES 168–173)
Images copyright and courtesy of
Monika Mogi

ELIZABETH RENSTROM (PAGES 174–177)
Images courtesy of Elizabeth Renstrom

MAYA FUHR (PAGES 178–181)
Images courtesy of Maya Fuhr

JESSICA YATROFSKY (PAGES 182–185)
Images courtesy of Jessica Yatrofsky

JOHANNA STICKLAND (PAGES 186–189)
Images courtesy of Johanna Stickland.
Photographer: Johanna Stickland;
models: Kara Neko, Brooke Labrie,
Janine Mizera, Kelsey Dylan, Peppina
Schwanengesang, Kate Somers

For trusting me, and for your guidance and encouragement:
Robert Shore and Marc Valli. For your patience, flexibility,
hard work and enthusiasm, all of which have shaped this
throughout: Felicity Maunder and Charlotte Coulais at LKP.
Special thanks to Zing for your compelling and insightful
foreword. To the Jansen family, the Warmans and the Alons,
the friends who supported me, I'm so grateful, and to Ale, Phil,
Yaara, Tamar, who listened endlessly, and especially to Gon.

And course, for your kindness and generosity, which is
so visible on these pages: Zanele, Pinar, Yvonne, Isabelle,
Deanna, Molly, Alexandra, Petra, Mayan, Jessica, Birthe,
Izumi, Monika, Mihaela, Rania, Lalla, Ayana, Lebo, Phebe,
Jaimie, Elizabeth, Lilia, Yaeli, Aviya, Petrina, Johanna, Juno,
Amanda, Anja, Aneta, Leah, Maya, liu, Maisie, Pixy, Shae,
Tonje, Nakeya, Nathalie, Marianna.